ART AT THE DAWNING
OF THE ELECTRONIC ERA
GENERATIVE SYSTEMS

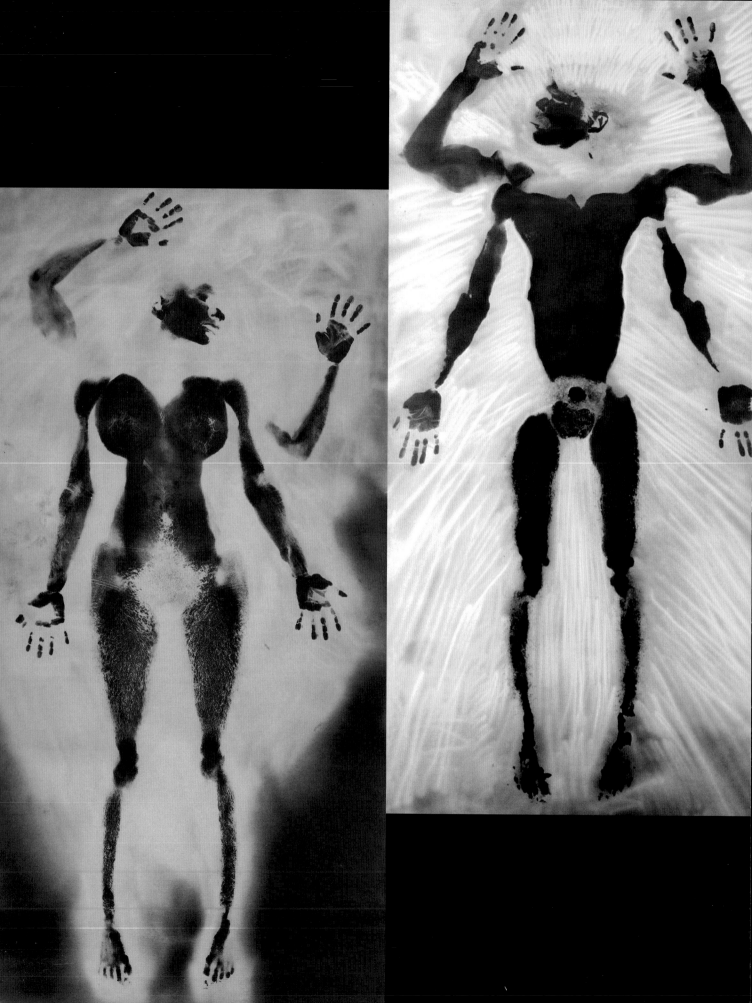

ART AT THE DAWNING
OF THE ELECTRONIC ERA
GENERATIVE SYSTEMS

Edited by Sonia Landy Sheridan

A GENERATIVE SYSTEMS BOOK

Lonesome Press, Hanover, New Hampshire

Distributed by University Press of New England
Hanover and London

Published by Lonesome Press
80 Lyme Road
No. 438
Hanover, NH 03755

Distributed by University Press of New England
Hanover and London
www.upne.com

Designed by Bodenweber Design

Printed by Puritan Capital

Cover: Brian Oglesbee, *Face-Face*. Collage with 3M Color-in-Color intermediate as the base and hand–applied crayon, pencil, oil paint, cut paper, etc.

Title page: Greg Gundlach and Martha Loving Orgain, *Body Print*. Xerographic developer print of body lotion on paper.

ISBN 978-0-615-88869-9

This book is dedicated to
Holly Smith Pedlosky
1943–2012

It was Holly who suggested creating the Generative Systems Facebook Group.
Her daughter, Dove Pedlosky, set up the group in 2010.

Table of Contents

1 **Introduction** by Sonia Landy Sheridan

5 **Through the Electric Doors of Perception** by Jacob Lillemose

11 **Generative Systems: (Re)Producing Hands and Faces** by Jo-Anne Green

15 **Generative Systems and the Transmission of Presence** by John Mabey

19 **The Generative Systems Digerati: Hands and Faces Go Digital** by Willard Van De Bogart

23 **The 1960s: The Precursors to the 1970s**

25 Stan Vanderbeek

28 Sonia Landy Sheridan

34 COSMO: Robert Frontier & Bill McCabe

38 Leif Brush

41 Douglas Dybvig

44 Joan Lyons

49 **The 1970s to 1980s: Fun Times**

50 John Dunn

52 Marisa Gonzalez

58 Greg Gundlach

62 Pete Lekousis

64 Philip Malkin

66 Brian Oglesbee

72 Martha Loving Orgain

76 Mitch Petchenik

80 Marilyn Goldstein Schultze

81 Glenn Sogge

82 Laurie Spiegel

84 Willard Van De Bogart

89 **The Contributors**

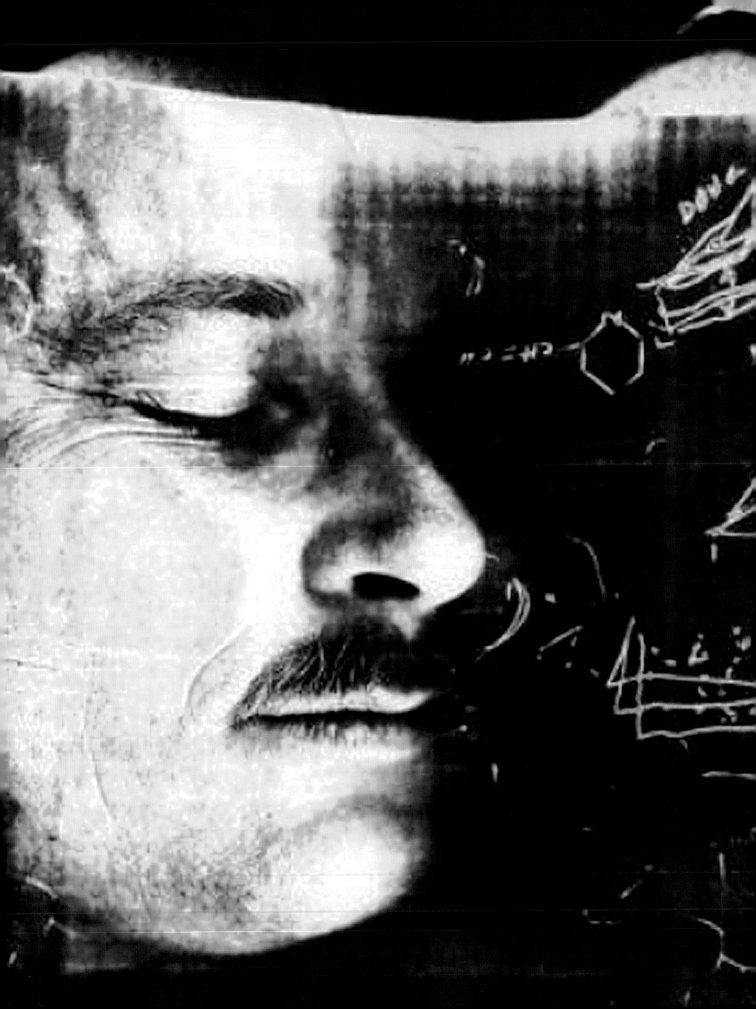

Introduction

SONIA LANDY SHERIDAN

Something unusual and special happens when an artist uses a communication system that is intended for commercial business use. A copy machine, used to reproduce data, may become a paintbrush. A fax machine, used to transmit data, may become a sound instrument for manipulating images. And a computer intended for business can morph into a system for creative use. From the 1960s electronic communication machines moved into public places, such as libraries and post offices. Artists, and people in general, were provided with new imaging systems to explore and play with. In the decades since, electronic imaging processes have exploded in richness and complexity. Electronic, technological progress is leading, in turn, to new biologic systems and a new body of creative people, once again, using commercially intended systems in unintended ways. This book, however, focuses on the 1970s, and is intended to reveal how early electronic systems were capable of being used to produce imaginative images, never intended or expected from business communication systems, but the very purpose and raison d'être of the Generative Systems program of the School of the Art Institute of Chicago.

Generative Systems is the name of a program that I established at the School of the Art Institute in 1970 and led for the following decade. The person responsible for the school catalogue and course listings first thought to call it Reproduction Systems because our central piece of equipment was a color copy machine. But when he found that our purpose was not to copy but to generate ideas and images that had never been seen before, he decided upon Generative Systems as the appropriate name.

Since we were using primarily commercial business equipment, we were in close contact with industries, and were generally treated kindly by them. None, however, was more important than the 3M Company. At the time we started, 3M had one of its newly invented color copiers under wraps in its Chicago office. It was called Color-in-Color, and was the first color copying machine. It was enormously sophisticated and flexible, with extraordinarily beautiful color, ideal for our purposes. The 3M managers and scientists could not have been more helpful and cooperative, and for the next decade they would be an integral part of our program. I spent one summer in the 3M Color Research Lab, and another half year in 3M Central Research at the invitation of Dr. Douglas Dybvig, the primary inventor of the 3M Color-in-Color. Dybvig has participated in each of our Facebook publications, and is also included in this one.

This book, *Art at the Dawning of the Electronic Era: Generative Systems*, began as a collection of faces and hands images that were playfully created with the technology of the 1970s. It is a project planned by the Generative Systems Facebook Group. That group was formed in 2010 by Holly Smith Pedlosky, an early graduate student in the Generative Systems program. While visiting the 2010 exhibition *The Art of Sonia Landy Sheridan* at Dartmouth's Hood Museum of Art, Holly

suggested that my Generative Systems should continue on a social network. With the aid of her daughter, Dove, a group was opened on Facebook. This was a natural choice, since with Facebook Group software, a small group of people can add photos, video, words, and create links. It was a creative way of using an open-ended system to bring together former students and colleagues, who now are located around the globe.

Since artists seem to prefer to make rather than talk, we soon decided to make the Facebook site a workshop. Our first production was *Exhibition in a Box: Sixteen Silk Scarves by Sixteen Artists 2010*. Each scarf was 36 inches square and printed using sublistatic dyes. These were the very dyes used in the 3M Color-in-Color machine. The next publication was the *Portable Postcard Exhibition 2* in 2011. It was dedicated to those artists in *Portable Postcard Exhibition 1969* who had since died. We planned to publish the Faces and Hands project in a similarly simple form, perhaps a box of images. Then something happened that changed the nature of the project and it became a book: *Art at the Dawning of the Electronic Era: Generative Systems*.

The event that altered the nature of the simple Faces and Hands project was an invitation to me by the Danish curator Jacob Lillemose to participate in a solo exhibition as part of Transmediale 2013 in Berlin, Germany. Our Generative Systems Facebook Group website became the vehicle by which I, and other members of that group, could observe the exhibit and comment on what was happening in Berlin. Lillemose became an active member of the group, offering commentary and raising

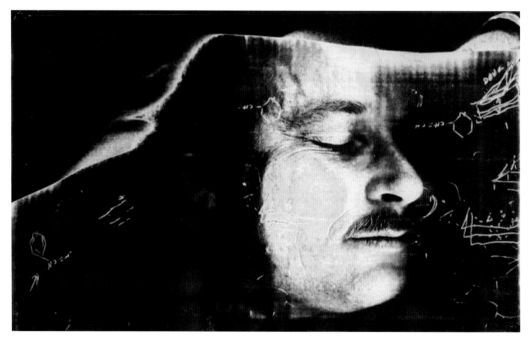

Doug Dybvig and Sonia Landy Sheridan, *Doug and Sonia Have a Visual Conversation,* mid 1970s. Collection of Langlois Foundation, Montreal, Canada.

Doug Dybvig and Sonia Sheridan have a conversation about structure on the 3M VQC black-and-white copier. Doug writes chemical structures. Sonia writes of layering as one relative way of visualizing time.

Exploration into new communication systems is exhilarating and energizing, for it can reveal new structures, images, sounds and ideas that, in turn, can trigger and generate an endless set of new possibilities. **Sonia**

Jacob Lillemose and Marisa Gonzalez in front of a blackboard at Transmediale 2013, Berlin, Germany. The blackboard shows one of Sonia Sheridan's daily messages sent via Generative Systems on Facebook.

questions. Our interest in the retrospective exhibition in Germany, combined with Lillemose's interest in the history of Generative Systems, added new dimensions to our thinking about Faces and Hands. Out of this welter of activity came a new conception of that project. Instead of a few images of faces and hands alone, we would set those images in context so they would illustrate aspects of the very beginnings of Generative Systems, the dawn of the electronic era. The pages that follow are the result.

The artists in this book are not all previous students of the School of the Art Institute of Chicago. Aside from the 3M scientist Doug Dybvig, there is Joan Lyons, of the great Visual Studies Workshop, early sound pioneer Laurie Spiegel, the futurist Willard Van De Bogart, and Stan Van Der Beek, with us during the 1970s until his death, and still with us. Most of the artists in this book were almost forty years younger when they made the images included in this book. This may explain a lot of the youthful humor and playfulness that made me think it a good idea to share this fun with another generation.

Through the Electric Doors of Perception

JACOB LILLEMOSE

The artist's playful interaction with technology permits the imagination
to develop alternate forms.

—Sonia Landy Sheridan, *The Inner Landscape and the Machine* (1974)

Technology not only offers us the practical means for more advanced and efficient ways of working, it fundamentally shapes our perception of the world. As the writer Mark Twain said of one of the most significant objects of analogue technology, "To a man with a hammer, everything looks like a nail." With technology in our hands we internalize the logic it embodies and come to see the world—and not least our role therein—through its prism of rational thinking. But does it necessarily have to be so? Can we not engage with technology in ways that shape our perception differently and allow us to see—to think and act—beyond the horizon of utilitarian reason? The artists affiliated with the Generative Systems program initiated by Sonia Landy Sheridan at the School of the Art Institute of Chicago certainly believed so and set out to explore the possibilities of such alternatives through their experimental activities spanning from 1970 to 1980. From the moment they got their hands on one of the many different machines that passed through the classroom, they challenged common notions of the right use of technology and expanded, distorted, and transformed its capabilities as a means of perception, opening a plethora of vistas to the undiscovered, unimagined dimensions of the new electronic world.

The explorations of Generative Systems followed the electronic revolution that radically reconfigured human life and society in the decades after the Second World War. The revolution was widely celebrated as the beginning of an era of endless opportunities and the birth of a new empowered man. However, one of the revolution's leading public voices, media guru Marshall McLuhan, was fundamentally concerned about the new situation. One of his principal worries was that we were essentially blind to the effects of the new technologies that were emerging around us and becoming an inseparable part of our accelerated modern existence. "We live invested in an electric information environment that is quite as imperceptible to us as water is to fish," as he put it in *Counterblast* (1969). This environmental blindness was natural considering the intensity and scale of the effects, but it nevertheless represented a risk to our comfort and happiness and even survival, according to McLuhan. In response to the situation, he argued for the need of so-called "counter-environments." These counter-environments would depict and discuss the new environment from a critical distance, thereby making it perceptible to us and helping us understand the radical and wide-ranging transformations that it had on our sense apparatus and consciousness.

Sonia Landy Sheridan, *Painting with Light* (detail). Cromemco Z-20 computer, Cat 2 graphic card, b/w surveillance camera, EASEL software by John Dunn, 1982. Collection of Hood Museum of Art, Dartmouth College, and Fondation Langlois, Montreal, Quebec, Canada.

McLuhan, who was trained as a literary scholar in the modernist tradition, believed that art was a privileged medium for the creation of such counter-environments. As he famously claimed, the contemporary artist had stepped down from the ivory tower and functioned as an antenna that was able to detect the imminent environmental changes of the new technologies. With this extended and fine-tuned sensibility the artist could make artworks that would prepare us for these changes, open our eyes and make us understand how the technologies—the "extensions of man"—worked, and not least how they worked on our perception of the world and our place and agency therein. Moreover, such an understanding would prevent us from turning into sheer "servo-mechanisms" of the technologies, and instead enable us to critically question them as well as to explore their enriching potential for our cultural development.

While McLuhan never mentioned any specific artworks that qualified as counter-environments, his ideas were extremely influential in the contemporary art of the time, which was discovering new art forms, concepts, and media. From the early 1960s, artists began to engage with the new electric technologies and the new environment that the technologies constituted in ways that intended to transform the blindness of automated use into knowledge, insight, and reflection. Rather than facilitating the consumerist fantasies of the "gadget lover"—to use another McLuhan term—the artists were occupied with the possibilities of developing and activating a critical literacy in relation to the technologies and their environmental effects. Like McLuhan, artists were aware that these effects —contrary to the positivist myth that accompanied the mainstream industrial and governmental promotion of technology—posed some fundamental challenges to human life and society.

The use of technology for advanced warfare and social control, robotics overtaking humans in the workplace and the private sphere, and dire ecological consequences of the accelerating demand for more power were just some problematic aspects of the emerging technologies that artists reacted to. In the face of these challenges they made work that presented an alternative experience with technology that recalibrated the sense apparatus and consciousness to encourage questioning of the new technologies. By conceptual, dramatic, and technical means, the works reconfigured the technologies in ways that distorted their identity as everyday objects of use and opened the possibility of a more analytical and reflective understanding. As such, the works not only aimed to create environmental awareness, they also pointed to a creative approach to the technologies, an approach that departed from the deterministic path which many saw as the natural consequence of McLuhan's diagnosis. While to him it did not matter if the machines produced Cadillacs or Cornflakes since the message was the machine itself, the artists demonstrated that unconventional uses, constellations and connections of the technologies were possible and represented a different —more humane, but also more imaginative—path for the development of technological life and society.

Integral to this questioning of the environmental transformations caused by electric technologies was a direct involvement with the technologies themselves. Instead of observing the situation from afar the artists took their point of departure in hands-on experiences. Informed by either basic do-it-yourself methodologies or advanced collaborations with scientists, they experimented with the capabilities of the technologies to open visionary perspectives, both for art making—technological invention—and for human interaction with machines as a psychological and social paradigm of the electronic age.

These experiments with technology have come to constitute one of the most significant strands in modern art history and in this history the Generative Systems program features prominently. Its ten-year lifespan within the institutional system is in itself admirable and unique, not least considering what Sheridan and the artists who participated in the research were getting their hands onto and into. In the spirit of the progressive political movements taking place around the institution, and the countercultural interest in alternative learning and knowledge production, the Generative Systems artists challenged the established educational context.

Generative Systems' philosophy, curriculum, and practices were informed by principles of an open lab in which the participants explored possible uses of various technologies—from Thermo faxes and color copiers to computers—that were not described in the accompanying manuals. Understanding how the technologies worked was fundamental to Generative Systems but only to the point that it allowed for experimentation. Hacking *avant la lettre*, technologies were being studied, pulled apart, reassembled, connected with other technologies, and eventually invented, guided by artistic concepts that challenged established notions of technological literacy, as well as the authority of technology, in the name of democratic and speculative imagining. That a vast number of the images created through the experiments of Generative Systems feature the hands and faces of the artists can be interpreted as a rather literal reflection of McLuhan's argument that media functions as prostheses that extend our mind and body. To a certain extent the images do express—and raise awareness of—this intimacy in the relation between the humans and machines. Yet, where McLuhan worried that the intimacy would feed a narcissistic impulse and eventually make us fall in love with the image of ourselves as technologically empowered beings, the Generative Systems artists used their hands and faces as immediately accessible objects for a continuous, high-frequency production of images. Rather than leading to self-absorption, the images served to facilitate a philosophical and aesthetic investigation of the technologies and the environment they constituted for our extended selves.

Generative Systems shared McLuhan's basic concern that the emerging electronic technologies blinded us to their transformative effects on our perception. However, it responded very differently to this cultural challenge. Contrary to his argument that understanding could only be created at a distance—"in the rear-view mirror"—Generative Systems was guided by a belief in creating awareness through engagement. Instead of cooling off the relation with the technologies as McLuhan's response implied, the activities of the artists brought about an intensification of the relation. Although the participants were instructed by Sheridan to conceptually formulate their experiments prior to their engagement with the technologies—otherwise, she believed that the technologies would dictate the experiments—once they were working with the machines they entered into a process of excited exchanges with the different functionalities and circuitries.

The close connection with the machines that the experiments at Generative Systems established compared to the experiments with drugs as mind-expanding technologies that had developed since the 1950s in both institutional and pop cultural contexts. Rather than numbing the sense apparatus and the mind like an anesthetic—this was the effect of media as narcotics according to McLuhan—the effects of the electronic drugs being used in the Generative System class was the amplification and deepening of the perceptual faculties. In her book *The Electric Garden* (1974), Sheridan makes a connection between a night of experiments with a kit for making Kirlian photographs using

Polaroid and a 3M Color-In-Color intermediate and Aldous Huxley's account of a mescaline trip in *Doors of Perception* (1954). Since the early 1960s flowers and plants had been recurrent figures in Sheridan's work, and she compares the glow of energy—"their living light"—that Huxley sees shining from the three flowers in the glass vase in his study with the aura around her and her husband's fingers that the electrically charged images exposed. Generative Systems was not a psychedelic experiment proper, yet through its experimental use of electronic—and later digital—technologies the class explored an experience of heightened sensitivity to color and the profound significance of objects like the one Huxley had during his trip. It simultaneously intensified, fine-tuned, and expanded the perception of the electronic environment towards qualities that lay beyond the purely technological.

Another important critical voice of the era, Herbert Marcuse, presented the dreary diagnosis that technology had come to replace human imagination, or rather that technological progress would become the horizon of our imagination. Contrary to the liberating potential of the artistic imagination, technology had the effect of repressing the imagination, producing one-dimensional man and one-dimensional society. According to Marcuse—with an implicit reference to McLuhan's bodily metaphors—we needed to develop "organs for the alternative" to the technocratic reason and rational logic that characterized this one-dimensionality. Generative Systems' use of artistic imagination to manipulate technology constituted just such an alternative. Opposed to the linear time of machine work and its logical conclusion in a planned, finished product, the thousands and thousands of images of faces and hands generated in the lab of Generative Systems originated in the spiral time of existential reflection through processual imaging. Every image opened the doors to more possible images in a continuous discovery of new visionary dimensions of creativity and human life in the electronic environment free from control and exploitation. Furthermore, looking at the images —and at technology and our relation to technology through them—from the perspective of today's digital environment, this discovery seems as relevant and promising as ever.

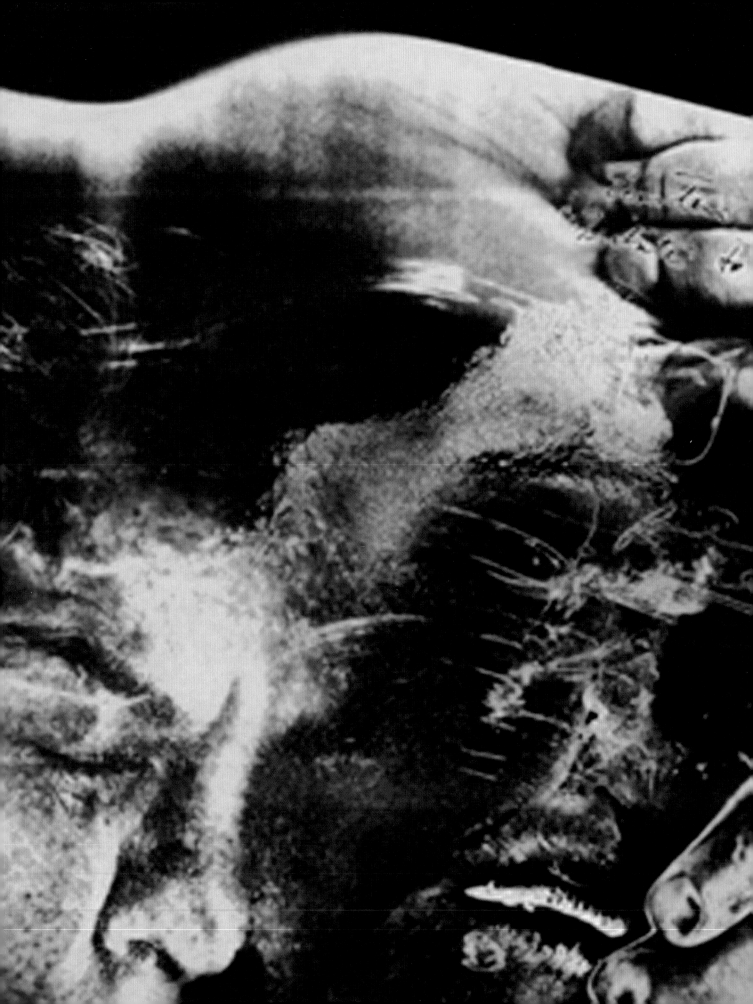

Generative Systems: (Re)Producing Hands and Faces

JO-ANNE GREEN

The surface of the mind trembles without cease,
Like the surface of the waters,
And like the waters
It assumes the shape of those forces
That press upon it.

—Roberto Calasso, *Ka*

Generative Systems' fascination with hands and faces calls to mind Wilder Penfield's cortical homunculus: In complex brains networks of neurons map their corresponding body parts, constituting virtual surrogates or neural doubles. However, the cortical homunculus is a distorted map, in that there is more space devoted to faces and hands than to the larger areas of the trunk and legs.[1]

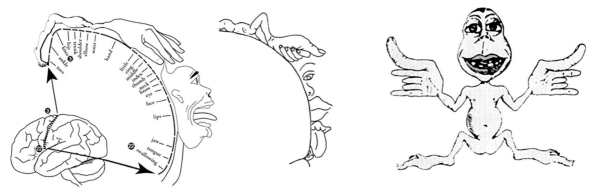

Homunculus, based on Penfield's classic diagram[2,3] The Cortical Homunculus as a figurine[4]

In Generative Systems' copied "Hands and Faces" series, the "so-called copy machine"[5] transcribes a 3-dimensional, living system (human mind-body) into a 2-dimensional representation of that system. Here the copier cannot serve its intended purpose—to create faithful reproductions of text/ image, information/document: if the "document" can be equated with DNA (an inert sequence of information), its copy is more analogous to mRNA, whereby, in the process of copying DNA, the cellular complex must read, splice, edit, i.e., translate and interpret the DNA sequence. The sequence is, thus, expressed, not copied. Fidelity is often sacrificed to ensure the survival of the replication machine, i.e., the cell. "(T)he music inscribed in the score does not exist until it is played, (and) players rewrite the score … in their very execution of it."[6]

Sonia Landy Sheridan, *Time and Time Again* (detail), 1974.

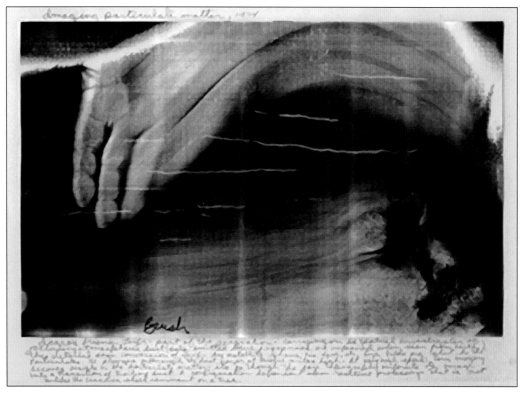

Imaging Particulate Matter by Leif Brush, 1974

 Of the 3M Color-in-Color copier, Sonia Sheridan wrote, "The most exciting feature of this system is … its capacity for instant production."[7] Just as our bodies constantly seek stasis, so do we in our creative outputs: as we create, we add, erase, and reassemble our compositions until they feel balanced.

> The artist … can now move (objects) about, arrange and rearrange them, cut
> them up, fold them, animate them, make any combination of colors within
> minutes. … I found the interaction of the various parts of the system a key to
> rapid, exciting image metamorphosis.[8]

This process is life (like), where life is a verb not a noun. The first "object" forms the basis or foundation of the next, each new "object" generating multiple more, each capturing the dynamics of the system (human mind-body) and mimicking its flux. Lived experiences are reconstructed and re-played: "some frames of recollection are dropped on the mind's cutting-room floor … to create new scenes that were never shot."[9] The mind-body and its creative process—manifested outside the body—are *autopoietic* (self-making). Stasis is achieved through movement. Constant change is a form of equilibrium. Reality is an "unending process … in which one *senses* unbroken, undivided process of flow.[10]

In these scanned/copied "Hands and Faces," the bright light of the machine slides across bodies, coaxing them into momentary suspended sleep, re-awakening them when darkness returns; an alien circadian rhythm. Pressed tightly against the glass bed of the machine, bodies sometimes seem confined; other times, they appear to be on the verge of breaking through, as if the surface is not impenetrable glass but, rather, water.

Epigraph quoted by Gretel Ehrlich in *Facing the Wave: A Journey in the Wake of the Tsunami* (Alfred A. Knopf, 1998), 60.

Frontispiece: "I pressed my face onto a white sheet of 3M VQC coated paper. Then placing my hand and face on the platen (sic), passed the VQC paper with my lotion coated face through the machine. The VQC takes a photo of my face, reveals the greased face and solarizes my hand. Almost 1/2 century later I may have forgotten the sequence, but the idea is correct—layering of face pressured onto paper with a layer of VQC copier image. But always using 3M C-in-C toner ..." Posted by Sonia Sheridan on Generative Systems Facebook Group. Retrieved from http://www.facebook.com/groups/generativesystems/, on June 20, 2013.

NOTES

1 "The principle seems to be that the most important and sensitive areas of the body are most generously represented in the map." Reith Lectures 1976: Mechanics of the Mind. Colin Blakemore, Lecture 3: "An Image of Truth Transmission," November 24, 1976, Radio 4. Retrieved from http://downloads.bbc.co.uk/rmhttp/radio4/transcripts/1976_reith3.pdf on June 16, 2013.

2 Retrieved from http://www.intropsych.com/ch02_human_nervous_system/homunculus.html on June 19, 2013. Used by permission.

3 Wikimedia Commons. Retrieved from http://commons.wikimedia.org/wiki/File:Sensory_Homunculus.png on June 19, 2013.

4 Retrieved from http://artandperception.com/2007/03/whiffs-of-north-american-modesty.html on June 19, 2013.

5 Sonia Sheridan, "Generative Systems." Retrieved from http://www.fondationlanglois.org/html/e/docnum. php?NumEnregDoc=d00035224&IndexPage=1990 on June 16, 2013.

6 Evelyn Fox Keller, *The Century of the Gene* (Harvard University Press, 2002), 63.

7 Sonia Sheridan, "Generative Systems." Retrieved from http://www.fondationlanglois.org/html/e/docnum. php?NumEnregDoc=d00035224&IndexPage=1990 on June 16, 2013.

8 Ibid.

9 Antonio Dimasio, *Self Comes to Mind: Constructing the Conscious Brain* (Vintage Books, 2012), 223.

10 David Bohm, *Wholeness and the Implicate Order* (Routledge Classics, 2002), x.

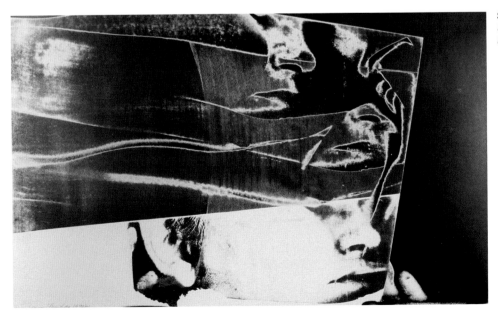

Sonia Landy Sheridan, *Layering, Stretching and Compressing Sonia in Time,* 1974.

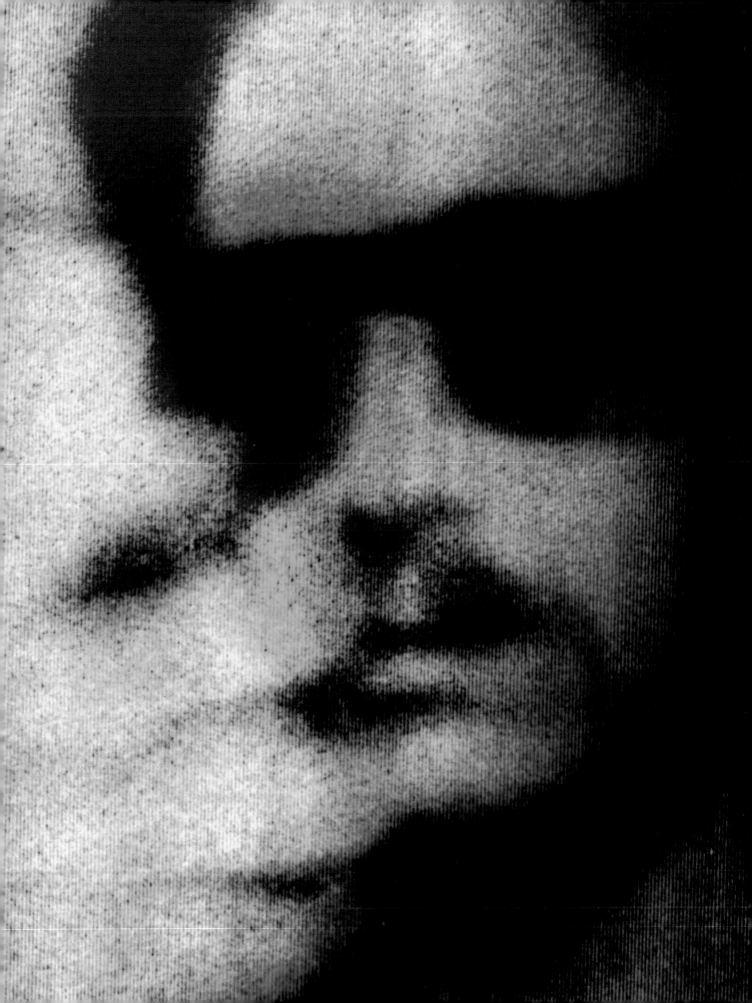

Generative Systems and the Transmission of Presence

JOHN MABEY

Take a tool and explore it fully. Learn to think with that tool.

—Sonia Landy Sheridan

I n the spring term catalog of 1977, the course offering was listed under Generative Systems as the Communications Research Workshop. Aldo Tambellini, then a fellow at the Center for Advanced Visual Studies at MIT, joined Sonia Landy Sheridan and 14 students for a practicum on media technology and art. The workshop was quintessential GS: hands-on experimentation, lively discussion, critical analysis, and an unselfconscious style of play were all equally welcomed.

> Sonia: The Graduate program in Generative Systems will be open to students that feel that art/science is not a threat to private contemplation. We are now living in an age where synthesis and specialization are complementary.

Twenty-first-century academia has since made accommodations to where the fringes of the visual arts once were: throw a rock in any direction from the center of a large American city today and you'll hit a university that offers a boundary-dissolving degree in something, but 30 years ago interdisciplinary studies in MFA programs were regarded as "experimental."

> Ed: The rate of technological change has never been this visible in the span of a single generation.

No one knew just how deeply networked media would transform global culture, but many were beginning to speculate. If you were in Chicago, a very good place to be was in the basement of the shiny expansion to SAIC where GS and the newly minted Time Arts Program were located.

Across town Illinois Bell Telephone was demoing its own version of the future with real-time interactive media branded as "The Picture Phone Meeting Service." Bell Telephone was betting on a technology that would offset the costs of executive travel with an alternative: the conference call. At the dawn of the electronic era, video telephony was low-res, analogue, and prohibitively expensive.

> Estimated development cost: $US 500M.
> Hourly rate LA/NYC conference: $US 2,380.

Appropriate to the spirit of the day, the group decided to do a performance exploring how artists would use this "telephone with pictures." A list of some of my favorite ideas that surfaced:

Philip Malkin, *Video Self-Portrait 1* (detail), 1976. 3M Color-in-Color print.

Have a blind person in one room and deaf person in the other room. Provide minimal instruction. Document how they would use the medium to communicate for the first time.

In one room, scan Sonia's body in fragments—deconstruct her. In the other room reassemble the sections—reconstruct her.

Four people in four cities casually engaged in conversation while moving their bowels.

Perform an octet telephonically—two string quartets jamming between distant cities.

I do not know what prompted Bell Telephone to grant our workshop access to the Picture Phone, but I am quite certain they never asked us to return. The lofty, philosophical meanderings soon gave way to the more fundamental issues of group dynamics and interpersonal communications …

Holly: We should all learn how to communicate face-to-face in real-time before we try to communicate through technology. How many people know how to live with someone, communicate through a child, teach what you are, who you are … learn?

… and a healthy skepticism about what the psychological consequences of an augmented medium would be like were it to become truly ubiquitous.

Sonia: (a) Our thoughts and skills are being extended electronically.
(b) Our thoughts and skills are being compressed and filtered selectively.
(c) What are the trade-offs that we will make unknowingly?

In contrast to Sonia's style, Aldo brought a hardboiled, Orwellian distrust to his analysis.

Aldo: Technology is not value neutral. Who owns the media? How do the interests of those who control distribution shape your perceptions? Ask yourself, whose financial interests are at stake, whose political interests are at stake?

In 1995 Nicholas Negroponte famously wrote, "Bits are the new atoms." And, indeed, this has become a headline for a digital life, in a digital world where information is abundant and where human

Hands of Generative Systems people in one Illinois Bell Telephone *Picture Phone Meeting Room* and a hand overlapping those hands in another room as the clock ticks on the screen.

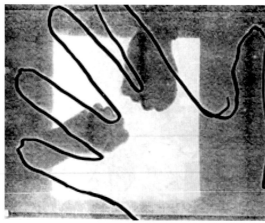

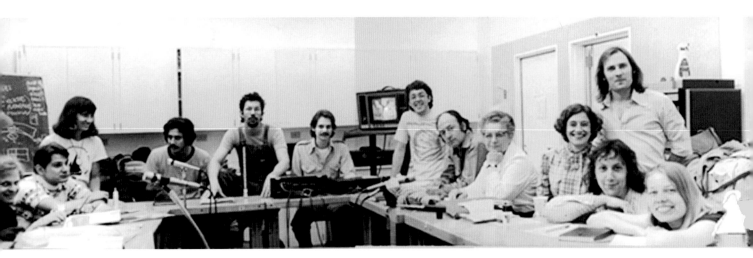

Generative Systems: The Communications Research Workshop: Aldo Tambelllini, Sonia Sheridan, and 11 of the students in 1977.

interaction is progressively mediated through screens. A world in which embodiment is the sacrifice when bits are conflated with atoms …

> Holly: Thursday, June 9, 1977. Epilogue. What can I do now, how can I synthesize? My note-book shows me as a filter but now I want to weave. Weave something I can wear. Something I can give to people I care about. "Art" and "Object" have become bad words in our group, but after a few years of **not** using them someone will discover that you can't give yourself, you can only give of yourself, and that part you give is an object (except when you are making love), and objects are nothing to be afraid of.

… and screens that target consumers are just as likely to be an instrument of power and control as enlightenment and education.

> Aldo: The medium is not the message, the real message is concealed by the media.

> Sonia: I love the polarity of it! With a Xerox machine Daniel Ellsberg revealed to the world what Nixon had done.

The Picture Phone Meeting Service was arguably the first attempt to virtualize the modern business meeting, and commercially it was a failure. Like the warm-blooded dinosaurs that turned into birds, the technology of the Picture Phone has adapted steadily over time and it owns a place in the lineage of media technologies that are increasingly mobile and social. In 2012 two products that offer similar functionality were introduced: Google Chat and Apple's Facetime. The transmission of presence is now an "app."

At the conclusion of the workshop, the journals of Communications Research Workshop participants were compiled into a TaSpace/Yony publication edited by Philip Malkin and Aldo Tambellini and distributed to the members.

Quotes from the journal of Holly Pedlosky Smith provided the foundation for this essay.

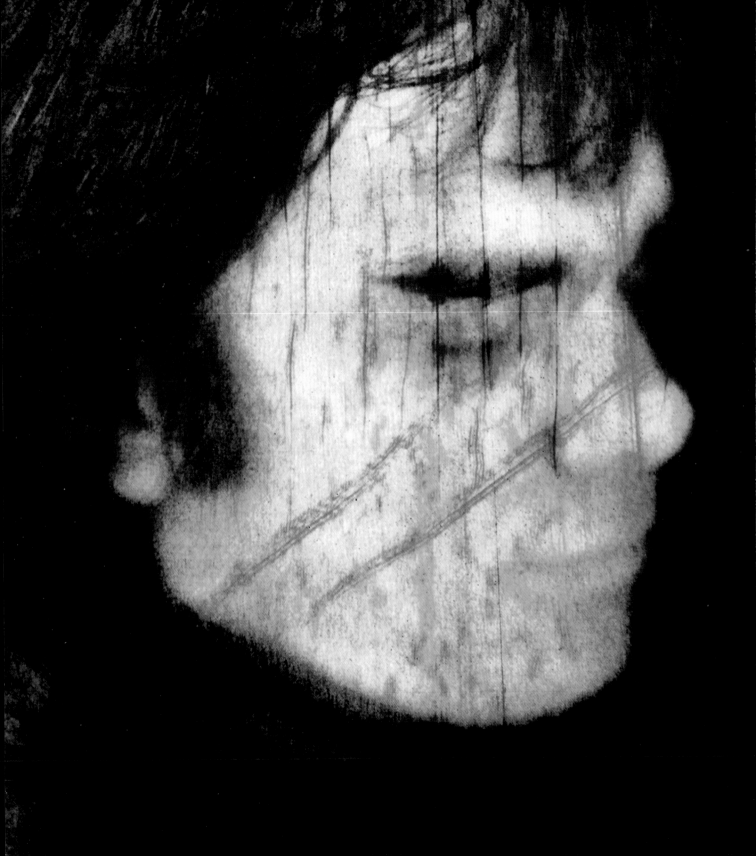

The Generative Systems Digerati: Hands and Faces Go Digital

WILLARD VAN DE BOGART

Apparently the decades of the 60s and 70s were an era when the imagination knew no bounds, and now, with the social networks propagating cyber space in the 21st century, they have become the new pallette, upon which Sonia Landy Sheridan's imagination is bringing together all those faces and hands she guided so lovingly over half a century ago. Subsequently, all those portraits created by the artists who were willing to be copied by the machine now appear among a million other faces seeking to speak again but in an era of mass social collaboration and innovation reaching every corner of the globe.

My own history with seeing faces and bodies transformed by loving machines was when I was working along side Nam June Paik and Shuya Abe in 1970, when we were modulating images on their Paik/Abe analog video synthesizer. The studio was in a most unlikely place called the Villa Cabrini Nunnery, home to the first campus of the California Institute of the Arts and located in Burbank, California. Then, after becoming a sorcerer's apprentice with the blessing of Walt Disney's legacy to the arts, namely Cal Arts, I ventured Eastward across the plains of America to soon find myself in another phantasmagorical environment called the Generative Systems workshop at the School of the Art Institute of Chicago.

If Los Angeles could boast talking mice and ducks, Chicago could boast a species of humans acting like hominoideas as they climbed over every copy machine, creating a Generative Systems media event where nothing was used in the way it was supposed to be used. This young sorcerer's apprentice met the Queen of Generative Systems arts who made the tastiest tarts by mixing inputs and outputs with all her loving machines only to be ingested by all. From slow scan transmissions over phone lines, to electronic signals recorded from one machine and sent to another, it seemed as if the birth of some form of expression that would solidify the marriage of art and technology was beginning to come into existence.

Fast forward half a century to the year 2012, which from a 60s perspective would have seemed like some future beyond imagination, but the future is here and it is still beyond imagination. If anything is noticeable about our world 50 years later, it is that it has become a landscape of spontaneous creativity unleashing into our 21st century a digital world that has changed the landscape with images so vibrant and so multi-textured that they seem to belong more to a distant future or some other world rather then the one we inhabit today. *Art at the Dawning of the Electronic Era: Generative Systems* is a new book announcing the dawn of the electronic era, but the evolution of technology over the last fifty years has undergone a generative systems process unequaled even with speculations from our time in the 60s suggesting the dawning of another era. *Art at the Dawning of the Electronic Era: Generative Systems* has been catapulted into a world where everyone sees

everyone and shares in a multi-cultural social matrix creating an interconnected global community. The Generative Systems hands and faces have become harbingers once again of another new era by attaching our forms and expressions to a world where anything can be shared, tagged, amplified, and literally put on a stage with millions of other members of the human family forming a web of expressions that was once a dream but now has turned into a reality that speaks a thousand tongues announcing a new digital era.

Sonia has taken the Chicago Generative Systems workshop and placed it in one of the world's largest social networks ever created, riding on the back of the internet. Who could have imagined in that castle of yore that by copying our faces for the Queen's tarts we would find our iconic images becoming the topping for an entity called Facebook? We have become the digerati in the Queen's court offering ourselves once again to be absorbed and transformed by forces we hardly understand.

As artists and as socially committed human beings Generative Systems has become the harbinger for yet another renaissance of artists who are now socially connected and who encourage others to set themselves free to find their own form and way of expressing in these uncharted times we are living in. The Generative Systems collective spawned a digital meme seeding the future under the covers of copy machines only to once again be copied and transformed anew. The thoughts Sonia sensed in those early days of exploration are now being played out by every artistic form imaginable. We are a family of real digital people playing, speaking, performing, and constantly being transmitted all over the earth and soon into outer space.

We are a Generative Systems digerati arriving in full color, 3D, 4D, HD, and ultimately transforming ourselves as we enter into another court in the Queen's castle. We have become cyber life-forms speaking to all our Facebook friends, and their friends, and ultimately creating a new form of expression and art form that is interconnected, interrelated, and international. It's been a long road since the days of those orange groves in Burbank, California, to the metropolis of Bangkok where I now reside, but I can still feel our community growing in ways I never thought possible. Thanks, Sonia, for bringing us all together again. The tarts are quite delicious.

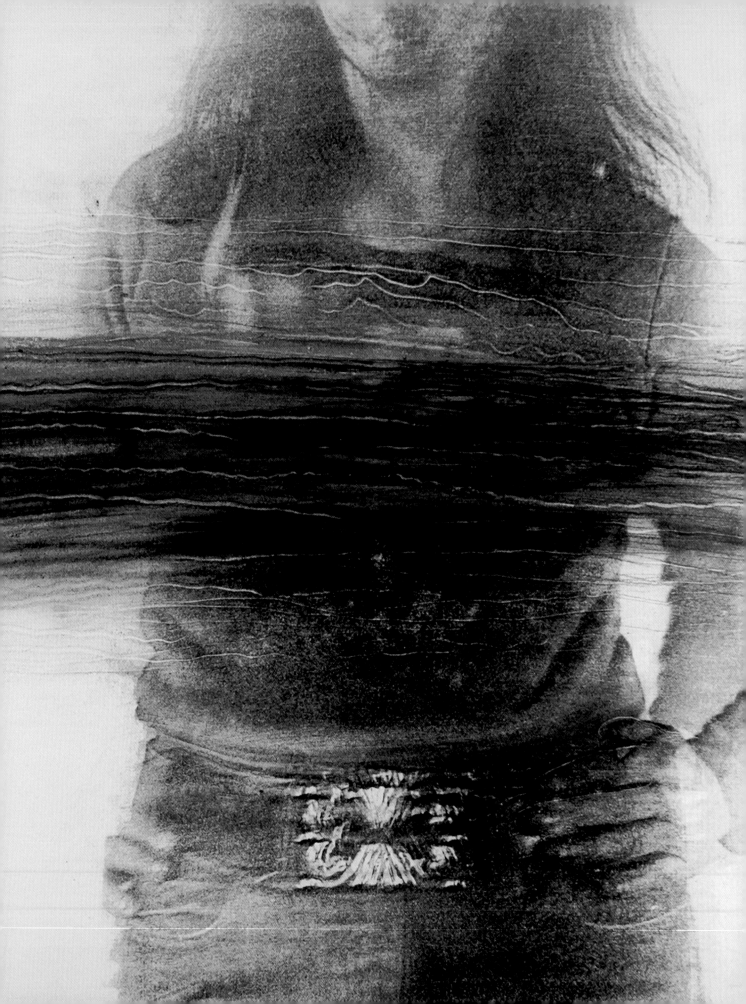

The 1960s: The Precursors to the 1970s

Fertilizing the ground in preparation for the emerging electronic technologies were individuals at the University of South Florida: Stan Vanderbeek (deceased); the School of the Art Institute of Chicago: Sonia Landy Sheridan, COSMO (Robert Frontier and Bill McCabe, the former now deceased), Leif Brush; the 3M Corporation, Color Research Labs, St. Paul, Minnesota: Douglas Dybvig; the Visual Studies Workshop, Rochester, New York: Joan Lyons.

Stan Vanderbeek

Sonia Landy Sheridan

COSMO: Robert Frontier & Bill McCabe

Leif Brush

Douglas Dybvig

Joan Lyons

Joan Lyons, *Drawing from the Hip* (detail), Rochester, New York, 1976. Haloid-Xerox transfers, rag paper with added pencil drawing.

How the Selection of Images and Captions Came About

Members of the Generative Systems Facebook Group periodically uploaded images dating from our work together decades ago. Among those images, faces and hands predominated. That was not surprising, because faces and hands were the most available objects to use in the heat and joy of playing with the early electronic imaging systems. Soon there were so many uploaded face and hand images that an album was created for them; a page from that album is shown below.

When we began to consider how we might use those images, we realized that they exemplified the work of the earliest attempts by artists to deal with the electronic era. Thus they constituted a kind of mini-history of Generative Systems at the School of the Art Institute of Chicago. That was timely, because there has recently been a rise in scholarly interest in the nature and significance of Generative Systems. We had our answer: we could produce a book using images already in our album combined with essays about Generative Systems. In the spirit of Generative Systems, we invited the artists to write their own captions, and to explain the process they used; this explains why the captions differ so widely.

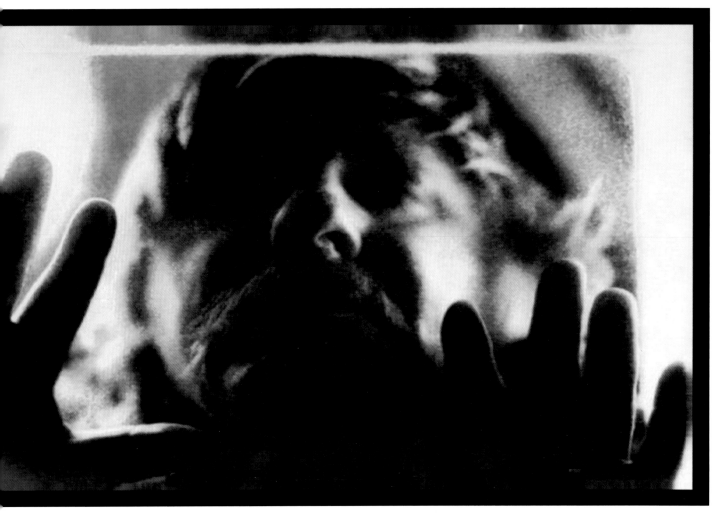

Stan Vanderbeek, *Self-Portrait*, 1969. 3M Color-in-Color. In the Sheridan collection at Fondation Langlois, Montreal, Canada.

Sonia Landy Sheridan, *Stan*, circa 1982. EASEL software by John Dunn, Cromemco Z-20, Computer Graphic.

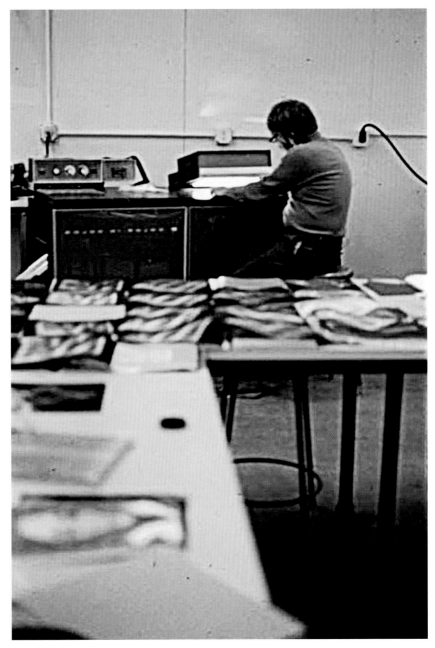

Stan Vanderbeek working with Sonia Sheridan in the Generative Systems early room, now the Chagall room, at the Art Institute of Chicago, 1975.

Sonia Landy Sheridan

Sonia Landy Sheridan, *Painting with Light*, 1982. Cromemco Z-20 computer, Cat 2 graphic card, b/w surveillance camera, EASEL software by John Dunn. Collection of Hood Museum of Art, Dartmouth College, and Fondation Langlois, Montreal, Quebec, Canada.

This is an example of painting with light by using a black-and-white camera while creating color with the EASEL software by John Dunn.

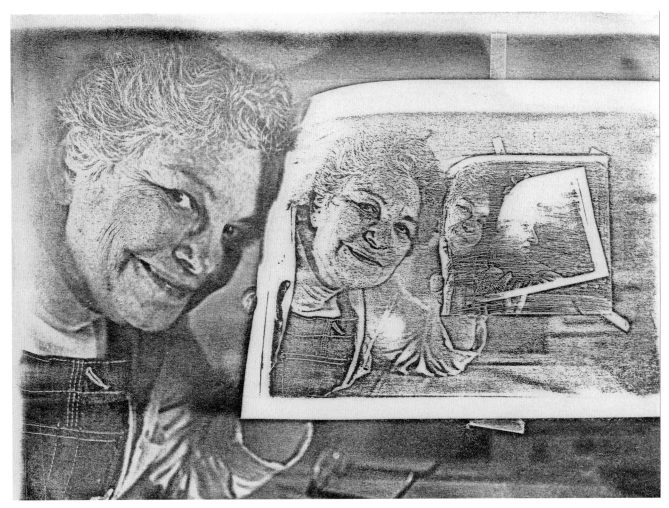

Sonia Landy Sheridan, *Sonia in Time*, with Diane Kirkpatrick, 1978. Haloid Xerox. Collection of the Hood Museum of Art, Dartmouth College.

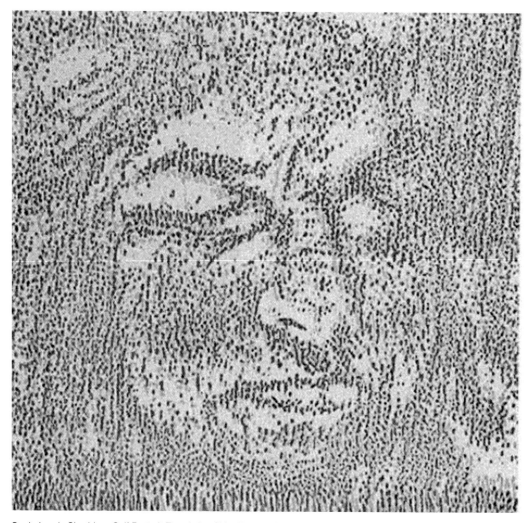

Sonia Landy Sheridan, *Self Portrait East Asian Side: Evolved from Westerner to Easterner*

Part 1 Face placed on platen of 3M Color-in-Color 1.

Part 2 Color image of face placed onto platen of a black-and-white Xerox copier. The b/w Xerox copy is copied, then that copy is copied until 100 copies of copies are made. The face is altered with each copy resulting in a face that starts out as a European face and finishes as an East Asian face. Evolution via copy machine.

Part 3 Each of the b/w copies is then placed on the 3M Color-in-Color 1 and rendered into color.

Part 4 Fifty of the color images are put onto transparencies, stacked together, and placed between two sheets of Lucite. Held up to the light the single face shows the transformation from Western to Eastern face.

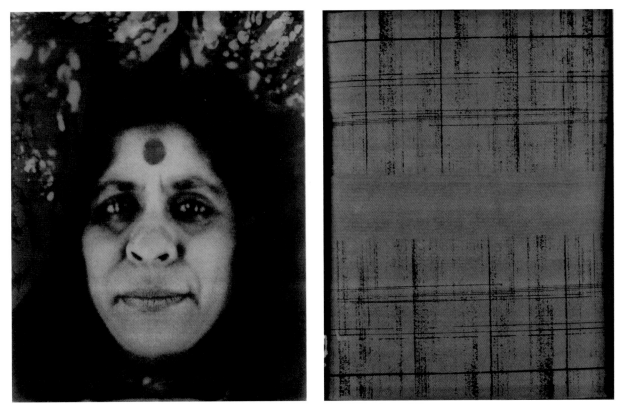

(left) Sonia Landy Sheridan, *Portrait of Kokkilam*. Collection of the Hood Museum of Art, Dartmouth College.

(right) Sonia Landy Sheridan, *Sonia Repeating Kokkilam's name on VQC*. Collection of the Hood Museum of Art, Dartmouth College.

The light color on Kokkilam's face was caused by a flaw in the 3M copier Intermediate. The design for the sari was made by repeatedly speaking the word "Kokkilam" into a 3M VRC remote copier that printed that sound-image in black and white. The black-and-white image was then placed onto the platen of a 3M Color-in-Color copier. By letting light seep under and around the VRC image the image is "painted with light."

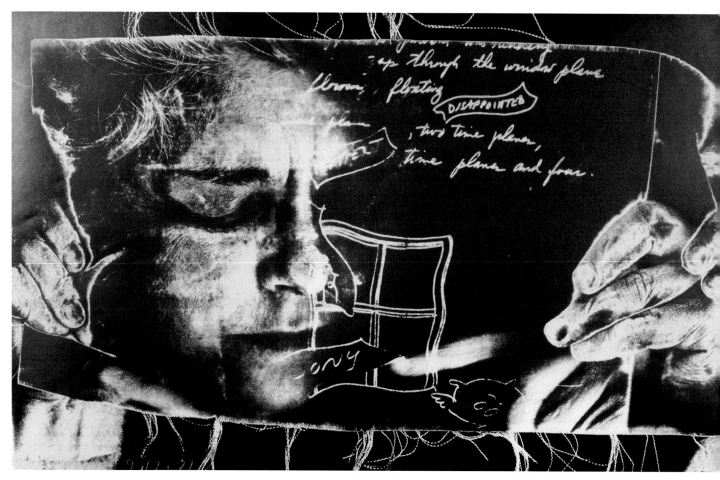

Sonia Landy Sheridan, *Self-Portrait with Cloth,* 1972. 3M VQC print using 3M Color-in-Color toner. Collection of the Hood Museum of Art, Dartmouth College.

An example of layering images in time, one after the other, one integrated and melding with the other.

Xerox Telecopier hand stretched to 72 ft.

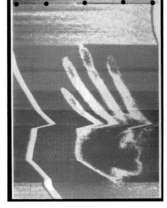

3M VRC remote copier and tape recorder

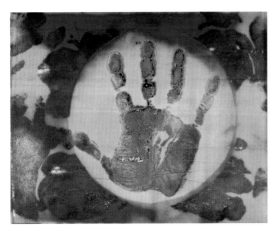

Hand pressure on 3M Dry Silver paper

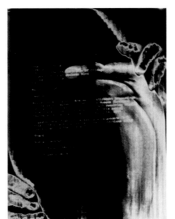

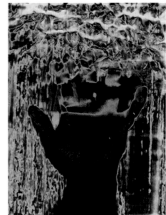

Motion on 3M VQC

Pressure. VQC image

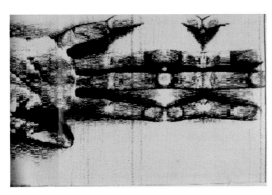

3M VRC remote copier and manipulation

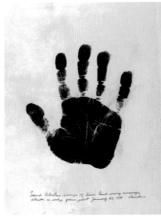

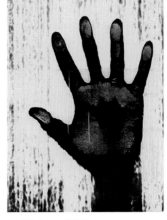

Pressure and vibration

Back light and VQC paper

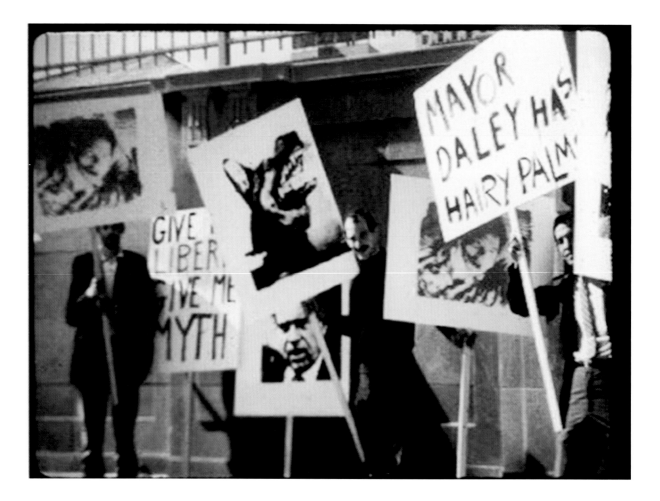

In 1968–71 conflict seemed to run the street in Chicago: baby boomers against their parents, many southern whites against freedom marchers, the American government against communism, women against men, students against teachers, and young people against any authority that threatened to inhibit their freedom.

In August of 1968, as demonstrators were assembling in Chicago for the Democratic National Convention, I sat next to Bob Frontier in a Michigan Avenue tavern near the Art Institute of Chicago. We discussed many topics: politics, culture, science, and art. Since we were both art students we talked a lot about art.

Robert Frontier was a complex and gentle man. His family radiated Italian decency and hospitality, so it was easy to understand the depth and source of his humanity. He was also afflicted by a painful condition that made it difficult for his body to eliminate poisons. On the other side of the coin, I was brash, impulsive and, perhaps, careless. My family had been standard American middle-class dysfunctional. But somehow, I was able to distract Bob from his daily bouts of pain, and he was able to file off the rough edges of my exuberance, sort of. We developed a partnership primarily focused on but not limited to experiments in photography and printmaking. We were an army marching off in all directions; anything was fair game: street art, sculpture, posters, films, apparel, etc. Subject matter was usually related to the social matrix of the time: war, politics, science, advertising, current events, business. Most of our work was carried off with a good-natured thumb-in-the-eye kind of esthetics and almost always thought of as transient satire. Though Frontier and I worked independently and together, we decided to create an alter ego named "Cosmo" as a shield against the negative impact of criticism and to remove personal uncertainty from our work. All of our art would be credited to Cosmo; Cosmo would take the blows; Cosmo would get the credit.

Much of the curricula at the Art Institute seemed irrelevant to the future practical needs of most students: figure drawing, painting (on large stretched canvases), etching (on wax-coated plates dipped in an acid bath), lithography (using heavy, difficult-to-grind stones). However, there were opportunities to take stimulating classes from other colleges and universities in Chicago. One of the most memorable for me was "Intelligent Life in the Universe," a physical sciences class at the University of Chicago, circa 1967. Such classes, along with a rich diversity of lectures, seminars, conventions, and gallery exhibits, made for a stimulating environment for learning, motivation, and activity. It was easy to see the rate of change in art, reprographics, and other technologies. When I began my studies at SAIC, teachers relied on mimeograph machines to make copies; by the time I entered graduate school, used copy machines were inexpensive and readily available. At the same time, Huey Reprographics offered several services that we were able to include as part of our imaging processes: blueprints, photostats, and large-scale transparencies.

In 1968 Robert Frontier was Sonia Sheridan's graduate assistant in "Serigraphy." It was not long before the three of us, and others, developed a feedback loop that encouraged exploration in imaging, communication, and collaboration.

—Bill McCabe

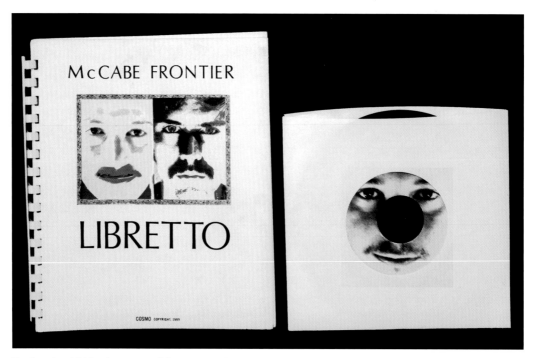

During the 1960s the team of Cosmo produced a wide variety of work that received much publicity for its witty commentary. One of the more private works was a small book titled *Libretto*. It was accompanied by two 45 rpm discs.

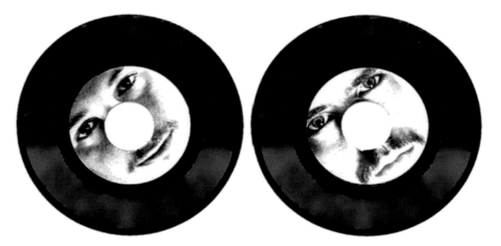

Self-portraits by Cosmo: left disc is Bill McCabe's face; right disc is Robert Frontier's face. (Robert died in Italy at the age of 25 years.)

The images in *Libretto* were made by photographing the discs while worn on their penises. The photos were then used to create silk screens.

Leif Brush

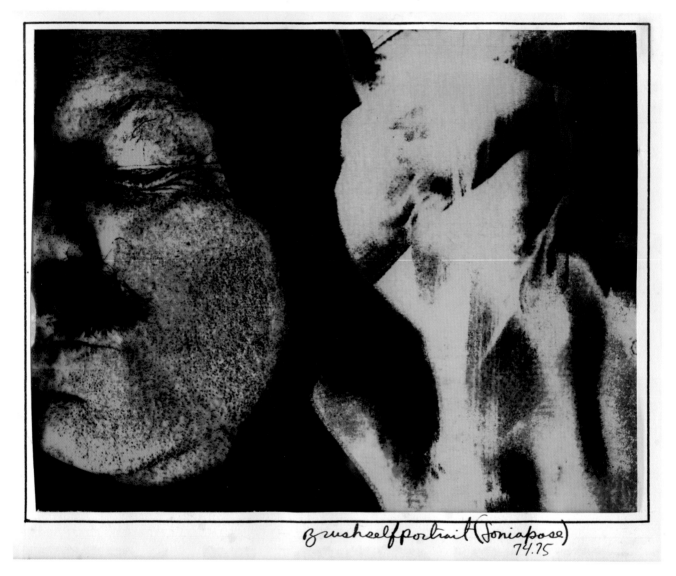

Leif Brush, *Self-Portrait (Soniapose)*, mid-1970s.

This was made in response to the moment I first cored a Douglas fir tree in our yard and heard, on my headphone, what sounded like a stomach growl. I later played back the cassette recording for our daughter while we were in my basement SOUNDROOM. My face and ear are juxtaposed with the imagined internal cellular expansions and undulations as the hot sun penetrated deeply into the tree.

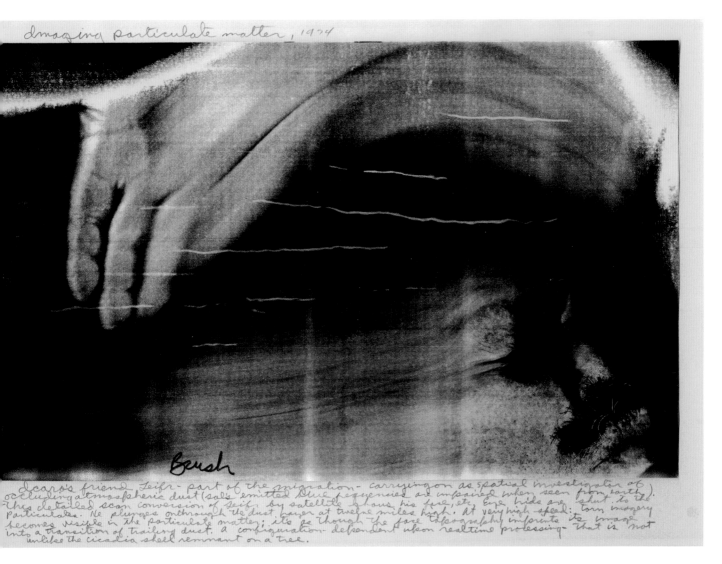

Leif Brush, *Imaging particulate matter*, 1974.

As derived from my housemother's readings that caught my attention as a child, I created detailed stories recounting Icaro's fall to earth. As Icaro's friend, Leifr, I was part of the migration, a spatial investigator of occluded atmospheric dust (sol's emitted blue frequencies when seen from earth). This zoomed scan of Leifr by satellite shows his face, eyelids shut to the particulates. He plunges on through time-space-matter, his facial topography imprinting an image into the trailing dust. Sonia's hand arches overhead and a flaw in the printing produces standing waves.

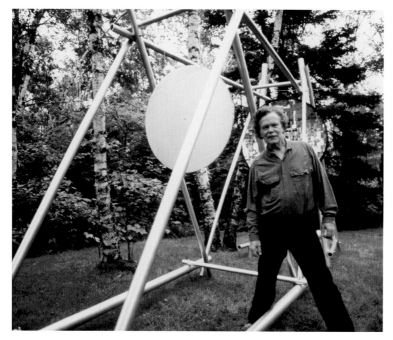

Leif Brush with *Telesuonohologram*

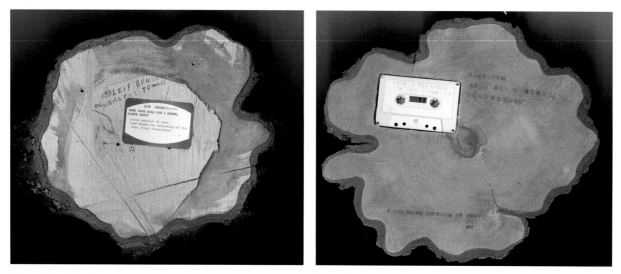

Mayor Daley's Tomb

Cross Section of Tree and Recording of The Tree Rings

"I only came to understanding trees when I heard their sap flow."

Leif Brush is best known as a leading sound-art pioneer. Here he describes his laboratory, a one-acre plot with "multiple Terrain Instruments whose functions were to transduce analog terrestrial phenomena: rain, snow, wind-stirred trees…and could be amplified for on-site listening and FM transmission. Conceptually, I wanted to simultaneously hear/broadcast all solar-powered Terrain Instruments at any given time. Not being able to do this in real time was disappointing. However…. I accomplished many analog recordings from all Terrain Instruments. Many are in the public domain. http://archive.org/index."

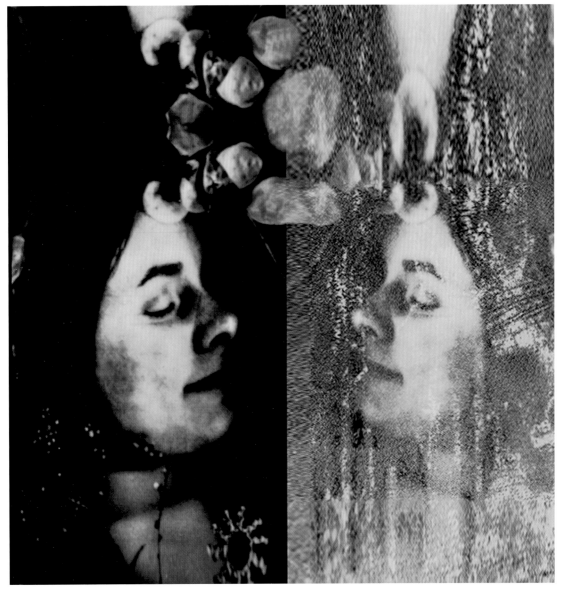

Douglas Dybvig, *Helen*, 2010. Silk scarf, printed with sublistatic dyes. Part of the publication *Sixteen Scarves: Exhibition in a Box*, first publication by Generative Systems Facebook Group.

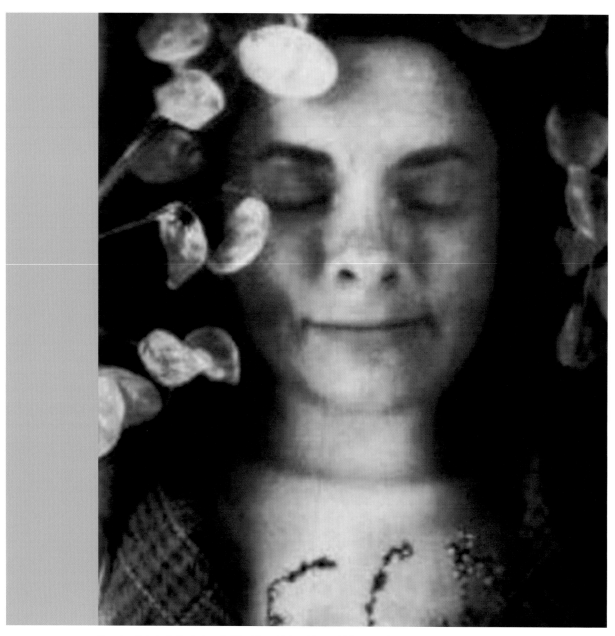

Douglas Dybvig & Sonia Landy Sheridan, *Helen*, 1974. 3M Color-in-Color print. Collection of the Art Institute of Chicago/Photography.

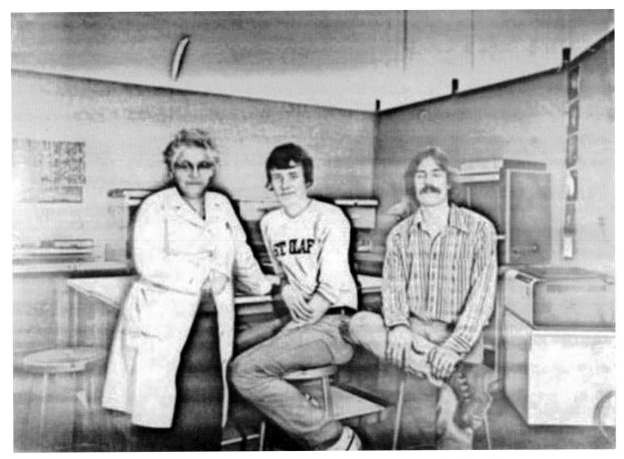

Sonia Sheridan, Rob Dybvig (son of Doug Dybvig), and Greg Gundlach (son of Robert Gundlach) in the Generative Systems room, circa late 1970s. Fondation-Langlois and Facebook images.

Greg Grundlach was a Generative Systems graduate student and Rob Dybvig was a St. Olaf's student visiting with his father, Doug Dybvig. The sons of two scientists responsible for inventing two important imaging systems are pictured together here. Greg received 4 patents for 3D photography and Rob became a medical doctor.

This image from the Fondation-Langlois was grabbed off Facebook. It is one indication of the constant interchange of images, comments, and information that provided the stimulus for this book. Interaction took place not only among scientists, technicians, and artists but also with the youth of the next generation.

Joan Lyons

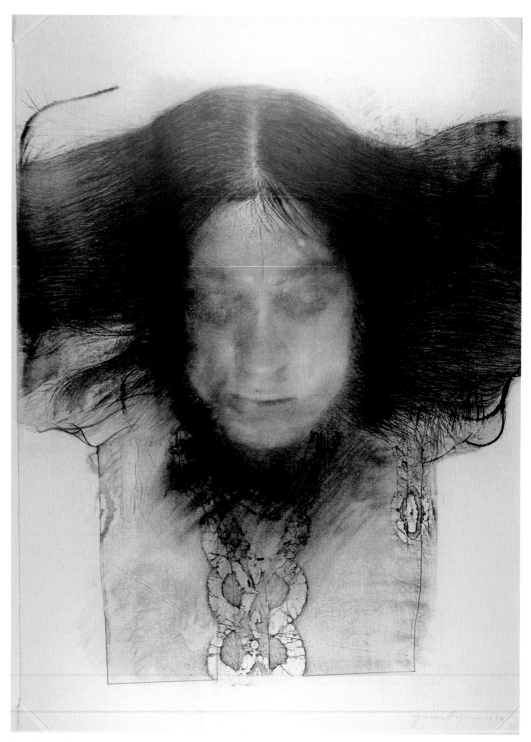

Joan Lyons, Untitled, Rochester, New York, 1974.

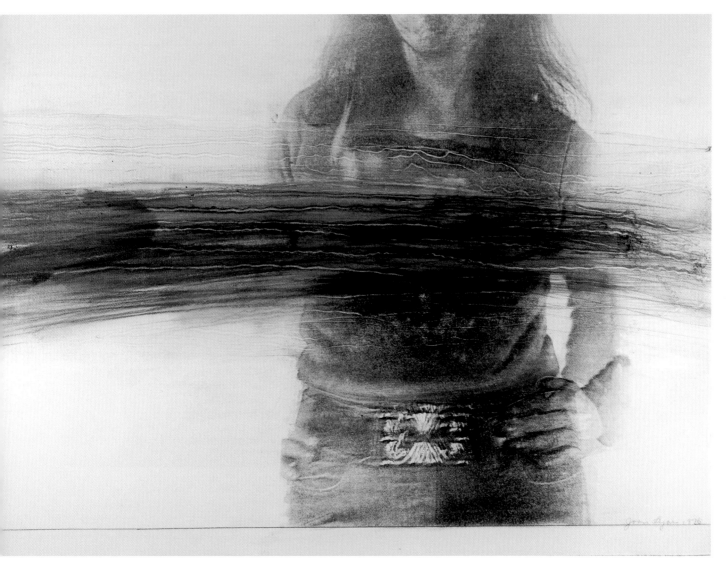

Joan Lyons, *Drawing From the Hip*, Rochester, New York, 1976. Haloid-Xerox transfers, rag paper with added pencil drawing.

Haloid Xerox electrostatic copier

The early non-automatic (1950s-era) Haloid Xerox electrostatic copier consisted of a copy camera and a separate processing unit that were used to image a selenium-coated plate. The image was transferred to plain paper and heat-fused in yet another unit. To make these images, the unfused toner images were transferred from sheets of onionskin paper onto the final paper support by drawing a negative charge through a straight pin clipped to a wire connected to the charge rail of the processing unit. This electrostatic transfer procedure was devised by Robert Gundlach. I also often used this process to transfer images to aluminum plates, which I printed on a Rutherford offset litho proofing press at the Visual Studies Workshop.

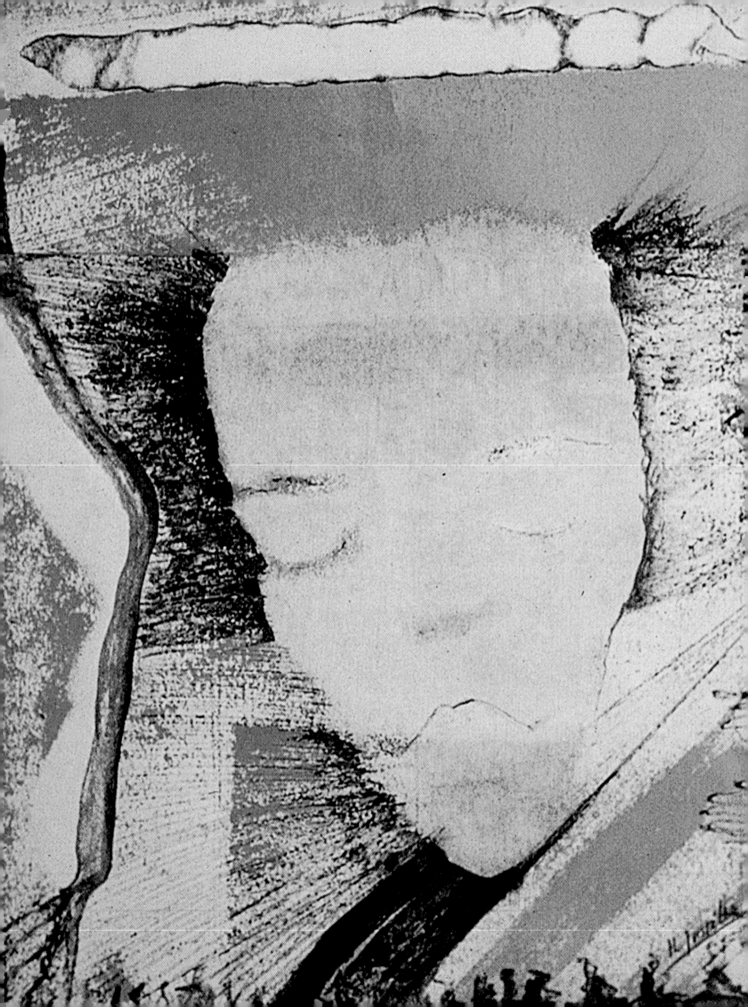

The 1970s to 1980s: Fun Times

This is the time when access to commercial communication technology began to be available to the public. Copy machines appeared in stores, fax machines became available, the 4K Radio Shack computer cost under $200, and old technology, such as the 3M Thermo-Fax, could be bought for a song. With social struggles at their height, artists, in need of more rapid communication media, looked for the communication technologies of the newspapers and television. The artists made posters and banners, but most of all, as artists, they began to play with the newly found equipment. It was fun times despite an era of great social strife.

John Dunn

Marisa Gonzalez

Greg Gundlach

Pete Lekousis

Philip Malkin

Brian Oglesbee

Martha Loving Orgain

Mitch Petchenik

Marilyn Goldstein Schultze

Glenn Sogge

Laurie Spiegel

Willard Van De Bogart

Marisa Gonzalez, *Self-Portrait GS* (detail), 1973. Mixed media.

John Dunn

Photo by Sonia Sheridan

The worlds of art and science have been bridged by composer and software developer John Dunn, who has been a pioneer in computer music and art since the 70s when he combined microcomputers and analog sound and video synthesizers as a graduate student at the Art Institute of Chicago, where he earned a Master of Fine Arts degree, mentored by Generative Systems founder Sonia Sheridan.

Dunn was one of the early programmers for Atari video games, and he developed the first ever professional paint program for a microcomputer, Cromemco's "Slidemaster," released in 1981. He went on to write a groundbreaking professional paint program for the IBM personal computer, called Lumena, and founded Time Arts Inc. of Santa Rosa, California, to market Computer Tools for Artists.

In 1986 Dunn wrote one of the first algorithmic composing programs for MIDI, MusicBox, which was released with full source code to the public domain two years later.

In 1988 Dunn began work on a new generation of creativity software based upon a synthesis of music, art, and science. This led to an exploration of genetic music, and in 1989 he wrote the first of several programs to convert DNA and protein genetic sequences into music. He has continued to evolve methods to reveal deeper, tertiary genetic structures, collaborating with Texas Wesleyan University biology professor Dr. Mary Anne Clark.

Quoted in part from Algoart.com, accessed July 2013.

This image from 1981 was taken with a prototype of an early image grabber for the 5-100 (pre-PC) microcomputer. It is one of the first—to the best of my knowledge it is the first—color video image captured with a microcomputer. In this case the Cromemco Z80 microcomputer and Digital Graphics Systems S-100 frame buffer were used.

Shortly after Cromemco had released my SlideMaster graphics software, I was contacted by DGS to port the SlideMaster software to the frame buffer they were developing. I'd written Slide-Master under an exclusive contract, but I had already begun work on a new graphics program under my own name and ownership that would become EASEL, later renamed Lumena.

There were no standard drivers back then, no drivers at all. This was all new, requiring a lot of trial and error experimentation. The image capture setup was primitive, a monochrome security video camera and a red/green/blue color wheel so three filtered shots could be combined into a single RGB color image. I worked with the video camera, pointing at myself as I programmed the image capture and smoothing and the color mapping. This shot was from a single scan, not using the color wheel, just false color mapping. I was creating color palettes for EASEL, and liked how it turned out.

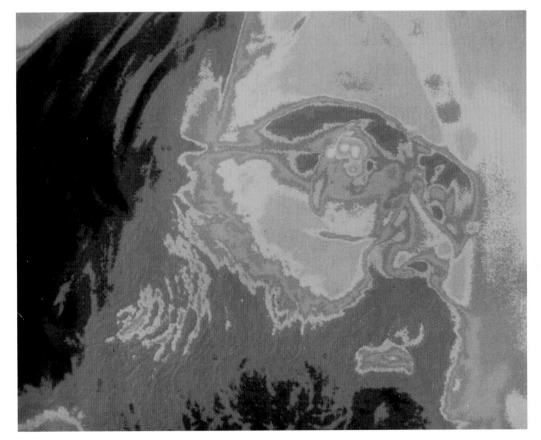

John Dunn, *Self-Portrait*, 1981. First color video image captured with a microcomputer.

Marisa Gonzalez

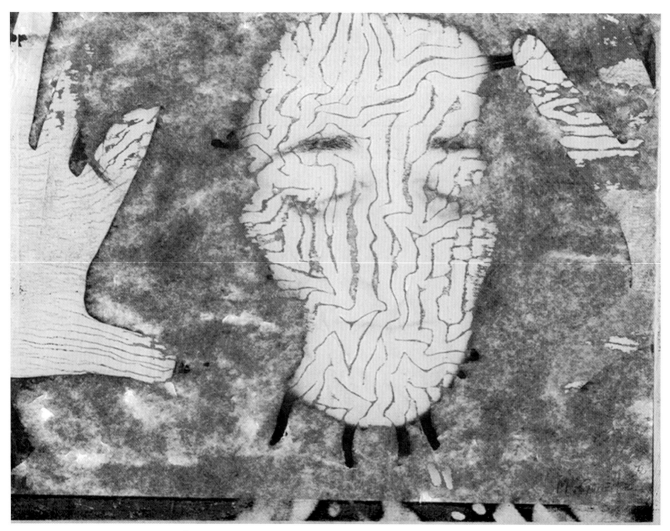

Marisa Gonzalez, *Self-Portrait Trace A*, 1973. Mixed systems.

Interactive papers: The original image comes from a collage from the 3M Color-in-Color machine that images black toner onto three mylar surfaces. On the other side of each of these three surfaces are yellow, magenta, and cyan sublistatic dyes. The black-and-white mylar image was altered by placing 3M Thermo-Fax B systems paper over it and heating it in a press.

Marisa Gonzalez, *Self-Portrait*, from the series: *Lumena Self-Portraits, Time Arts Computer, John Dunn Lumena Software.* Computer Graphic Lumena software.

Marisa Gonzalez, *Self-Portrait With Lint*, 1980. 3M VQC with Color-in-Color toner. A postcard from my exhibition *Presencias, lint* surrounded by white cotton.

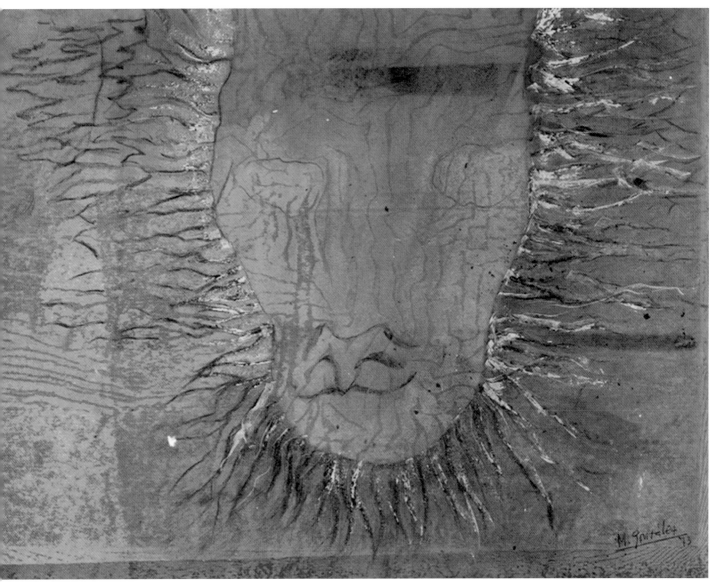

Marisa Gonzales, *Self-Portrait*, 1973. Mixed systems.

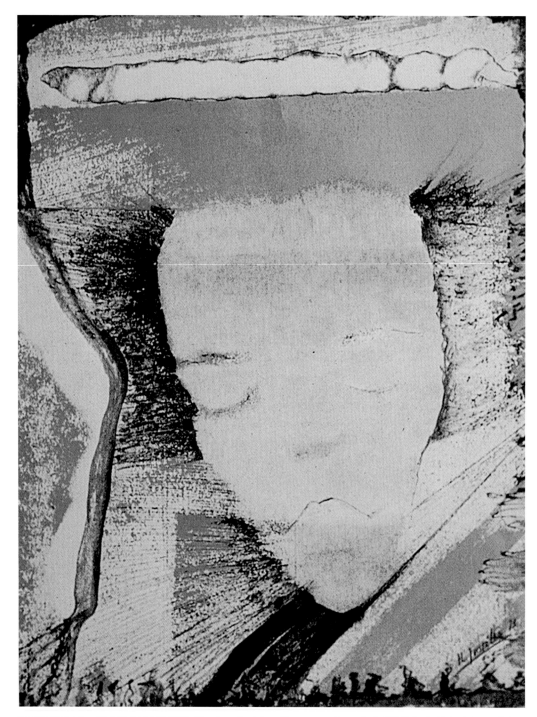

Marisa Gonzalez, *Self-Portrait GS*, 1973. Mixed media. Interactive papers: the color is 3M Color-in-Color intermediate transferred to 3M B systems paper with a heat press. Lines made with soldering iron.

Marisa Gonzales, *Photo Collage*, 1972. Generative Systems with Douglas Dybvig, inventor of 3M Color-in-Color system, and working students.

Greg Gundlach

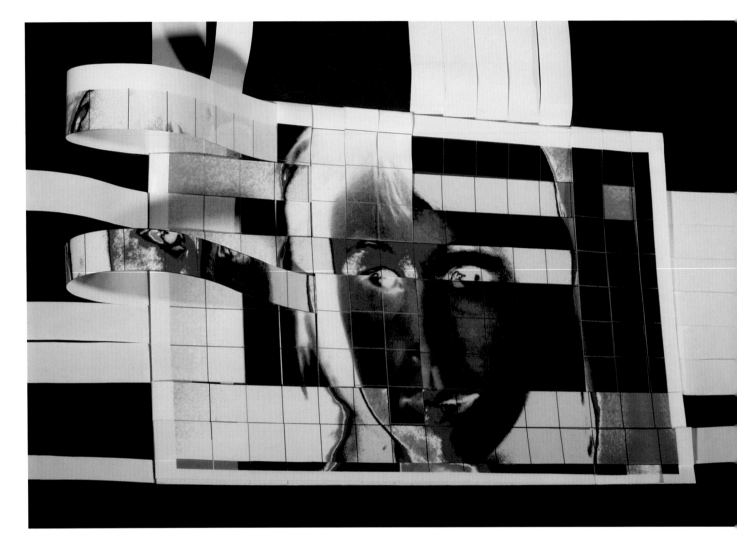

Greg Gundlach, *PuzzAlexa*. Dye-sublimation print.

This is a photo of an interactive piece that began as a photo of Alexa Lee taken at the Techtron Studio with Michael Day. The photo was digitally processed in a variety of ways, and select versions were printed and laminated. I cut and mounted these together so that they could be woven in a variety of ways. It was first displayed at the "Electronic Book" exhibition at the Evanston Art Center, Evanston, Illinois.

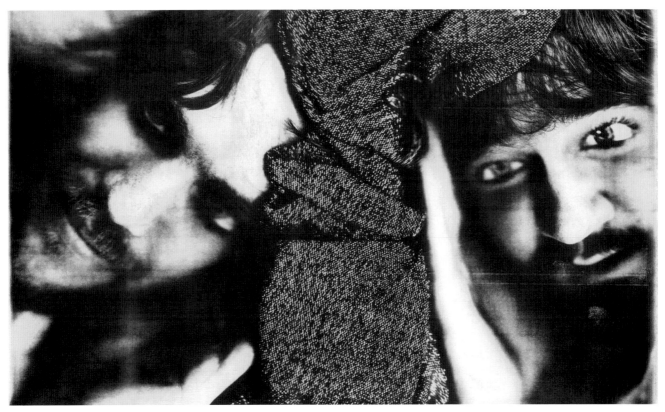

Greg Gundlach, *GGGM79VQC*, 1979. VQC print.

Grayson Marshall and I made this print on the VQC machine in the Generative Systems room at the School of the Art Institute of Chicago. We painted our eyelids because the VQC light was blindingly bright. Fun series with the VQC and Color-In-Color.

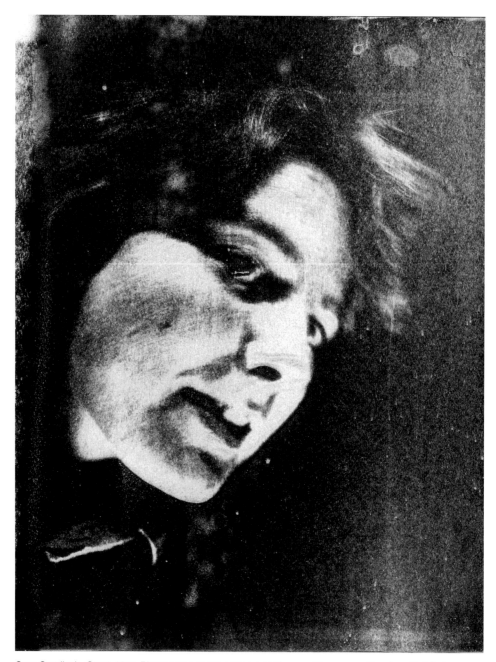

Greg Gundlach, *Stacy*, 1975. Photographed with a #1 Haloid Xerographic camera. Developed/printed on a Model D (flatplate) Haloid/Xerox processor.

The #1 camera was a gray box with a glass window on top. My father used #1 and #4 cameras with the Model D processors to do research on xerographic processes throughout his 43-year career at Xerox. The #1 camera was built in the early 1950s.

One of a series of full-size Body Prints created at my apartment and in the Generative Systems room at the School of the Art Institute of Chicago.

We would put lotion on our bodies and then lie on large sheets of paper.

By cascading developer (Xerographic toner coating, small steel beads) over the paper the image was revealed.

I used an airbrush (air only) to blow away some of the excess toner. That made the light streaks in the background.

We fused the toner to the paper by heating the paper with quartz lamps that I had purchased for studio photography. They were very hot and we had to be careful not to burn the paper as we moved them 4 or 5 inches above the surface. When the toner started smoking, it was done. We had to move the operation to the back yard to keep from setting off smoke alarms. Sometimes the paper caught fire. It was exciting.

There is something very primal about these images. They have fire, hair and pores, pressure, nudity, immediacy and scale. The black is essentially the same carbon as used in ancient cave paintings. I have always found them very powerful.

Magenta, cyan, yellow, black, and mixed-color body prints were created by the same process in the Generative Systems room at SAIC. We even imaged the doors to GS with multiple body print figures.

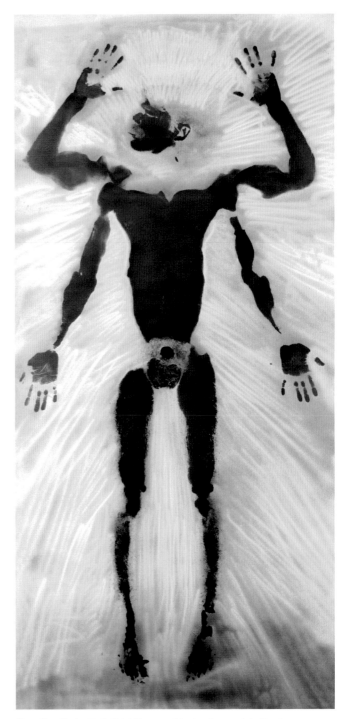

Greg Gundlach, *Body Print*. Xerographic developer print of body lotion on paper. Created in 1979 in my apartment on Fremont Street in Chicago.

61

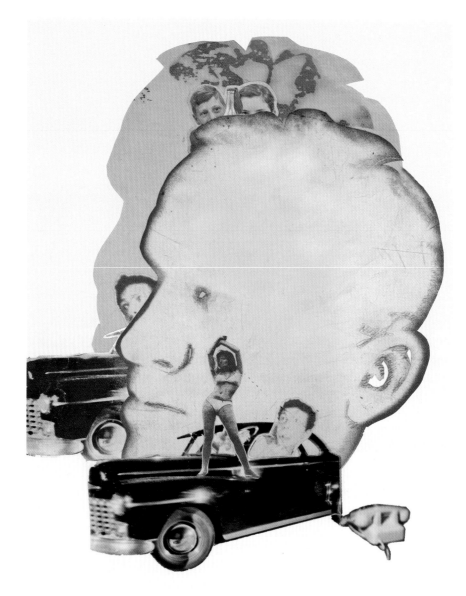

Pete Lekousis, *Urge*, 1972. 3M Color-in-Color intermediate (large head and man in car), silver photo prints, collage (Xerox and book), colored pencil, photo dry mount tissue.

All the time this image was being created I was trying to blend elements from machine-rendered imagery (3M Color-in-Color copier, photomechanical processes) with collage and hand-applied color pencil and scratches. Sonia Sheridan and Keith Smith encouraged my efforts in this direction, which ultimately led to the creation of a book of images using similar techniques, but also using sewing with thread and windowed pages, which further visually manipulated the images.

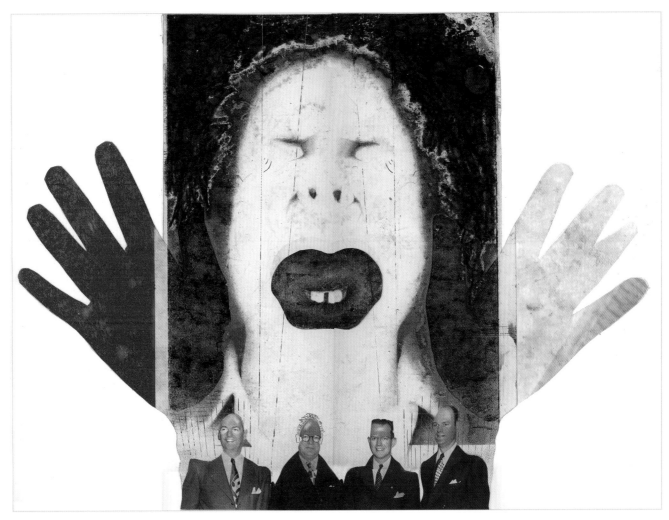

Pete Lekousis, *Pins*. 3M Color-in-Color intermediate, photo silver print, color pencil. Large face image and hands are a piece of 3M Color-in-Color stock, collaged together with hand-colored, shape-manipulated, silver photo print.

Philip Malkin

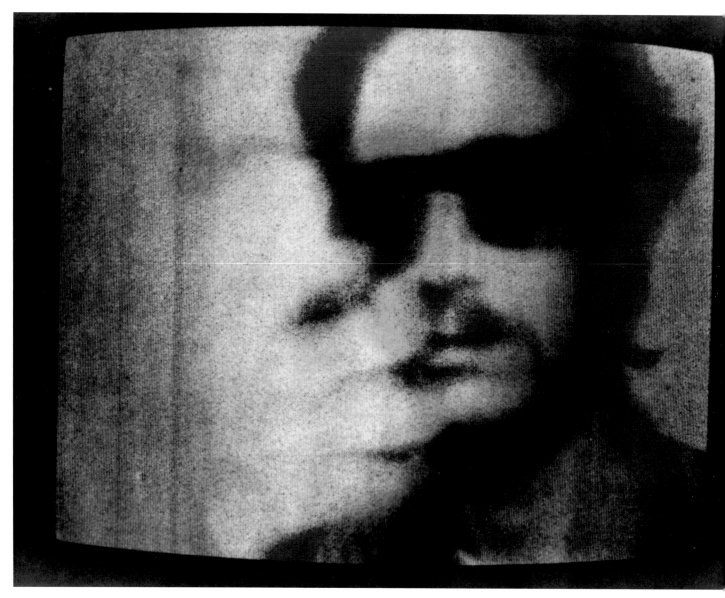

Philip Malkin, *Video Self-Portrait 1*, 1976. 3M Color-in-Color print. Live video feed from a black-and-white video camera to a Sony 12" Trinitron monitor scanned with the 3M Color-in-Color photocopier.

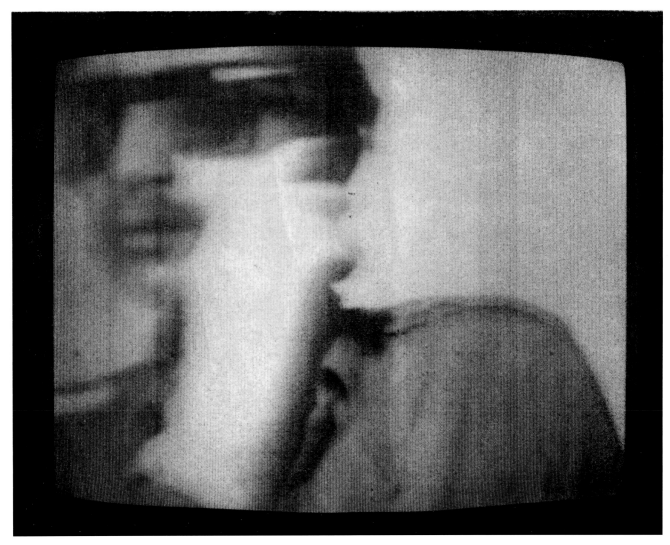

Philip Malkin, *Video Self-Portrait 2*. 3M Color-in-Color intermediate cell back. Live video feed from a black-and-white camera to a Sony 17" Trinitron monitor scanned with the 3M Color-in-Color photocopier. The intermediate material was retrieved from the Color-in-Color final print.

Brian Oglesbee

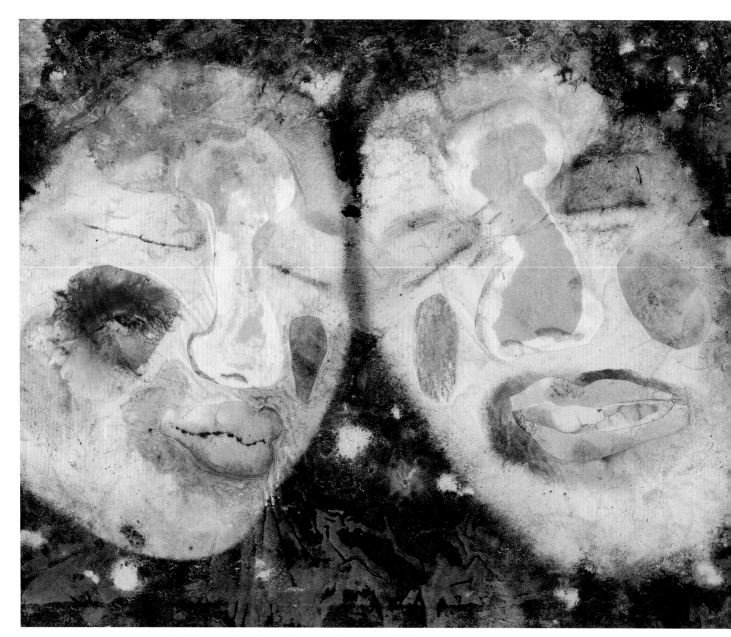

Brian Oglesbee, *Face-Face*. Collage with 3M Color-in-Color intermediate as the base and hand-applied crayon, pencil, oil paint, cut paper, etc.

I made a sandwich out of a piece of 8" x 10" sheet film stripped of its emulsion and a piece of Color-in-Color intermediate with crayon, cut paper, etc. in between and cooked it in a dry mount press at high temperature for 45 minutes.

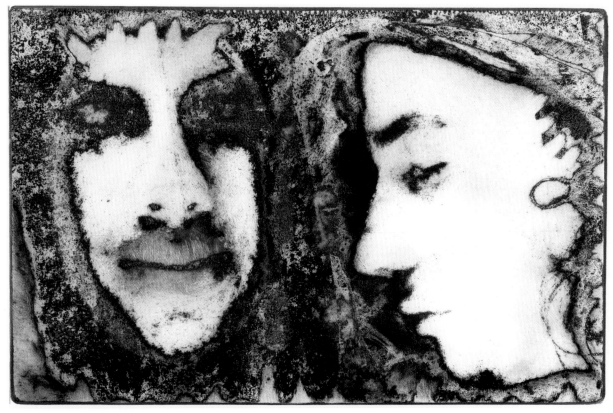

Brian Oglesbee, *Pete and Brian*, Chicago, 1972–73. Etching with heavily manipulated 3M Color-in-Color intermediate that was used as a resist after heat fusing to a copper plate.

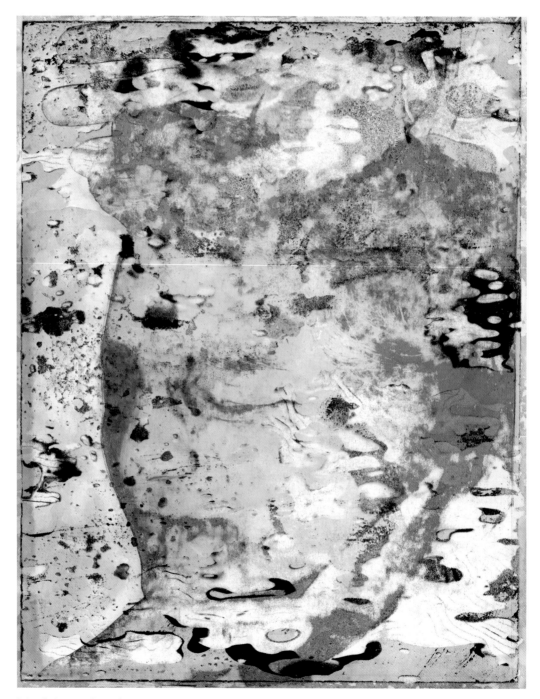

Brian Oglesbee, *Sonia*. Sonia's face-and-hand image is cut out of a piece of 3M Color-in-Color mylar intermediate material and heat-fused to a piece of heavy paper. The resulting image is very gray in color. The ink and black elements were also generated with heat and Color-in-Color by-products, but this time on clear vinyl. The result was intended to end up part of several pages, like an illustration in a biology book where you peel back layers to reveal more and more.

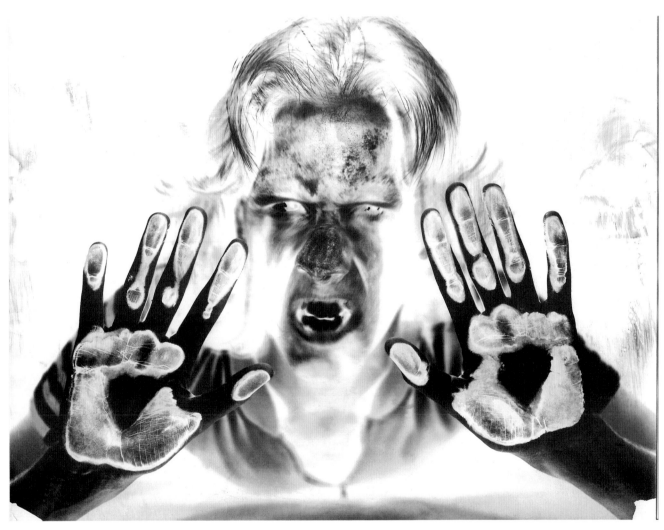

Brian Oglesbee, *Self-Portrait*

Q: How do you find out if you could be Positive and Negative at the same time?

A: Dip your hands and face in the Gundlach toner tray and make an exposure with the Haloid copy camera in the GenSys room using a piece of 8" x 10" photo paper.

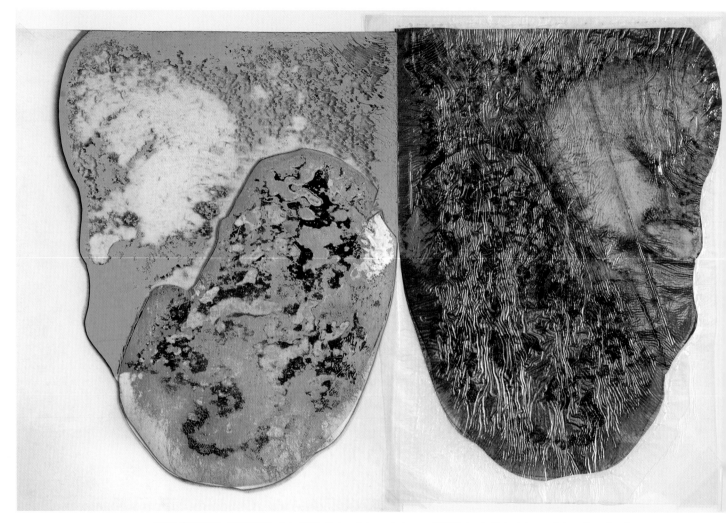

Brian Oglesbee, *Keith/Keith*, circa 1971. Cut and shaped pieces of 3M Color-in-Color intermediate collaged and heat-fused to cleared photographic sheet film and acrylic plastic. These were pages of an unrealized book featuring transparent areas that were meant to assemble and disassemble images as the pages were turned.

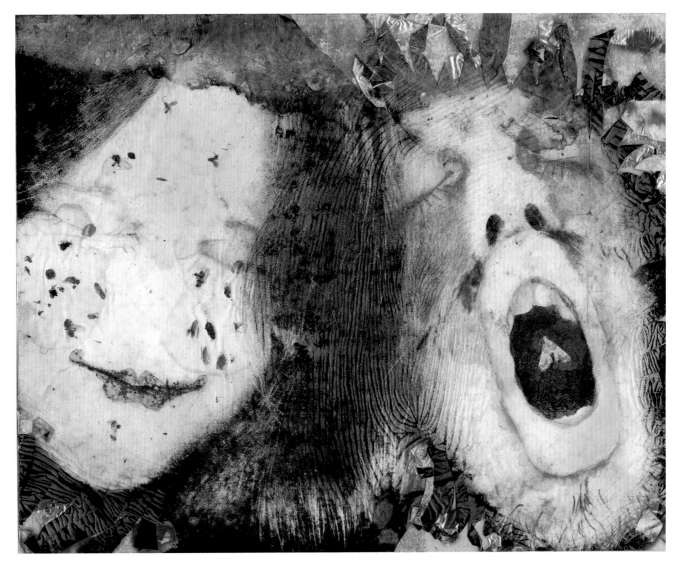

Brian Oglesbee, *Self-portrait with Friend*. Collage comprised of 3M Color-in-Color intermediate heat-fused to a sheet of cleared 8" x 10" sheet film in a dry-mount press. With colored pencil, oil paint, crayon, gold leaf, and insects.

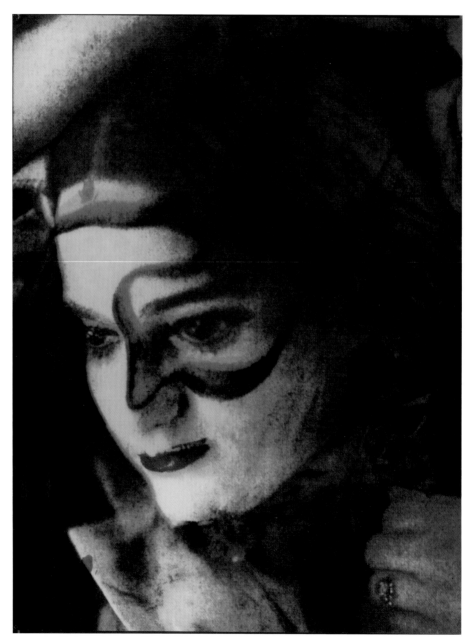

Martha Loving Orgain, *Magic & Mystery 1*, circa 1979. 3M Color-in-Color print.

One day we were fooling around with the color machine and we took the glass platen off. We knew it was dangerous to have your eyes exposed to the bright light so Greg painted my face with shining eyes on top of my eye lids so it would look like I had my eyes open in the image. I did a whole series of these and still have about 8 or 10 of them.

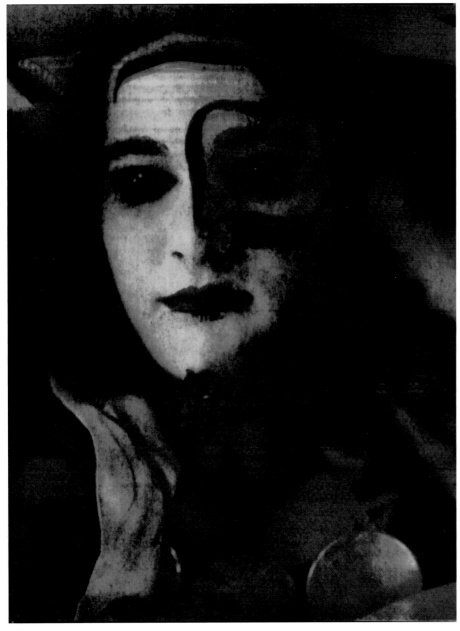

Martha Loving Orgain, *Magic & Mystery 2*, circa 1980. 3M Color-in-Color print.

Second in the series of painted faces. I was wearing my white lab coat that had images of my hair printed on the lapel. Real and surreal. Mixing realities, hair marks, streaking with primary print colors.

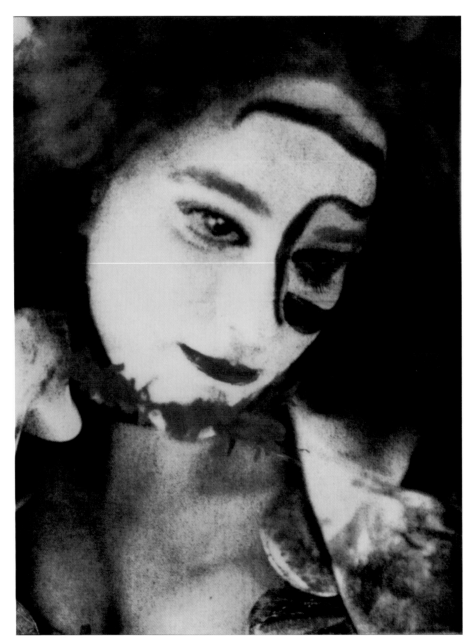

Martha Loving Orgain, *Magic & Mystery 3*, circa 1979. 3M Color-in-Color print.

Third in the series. The coral necklace emerges from the darkness into the light.

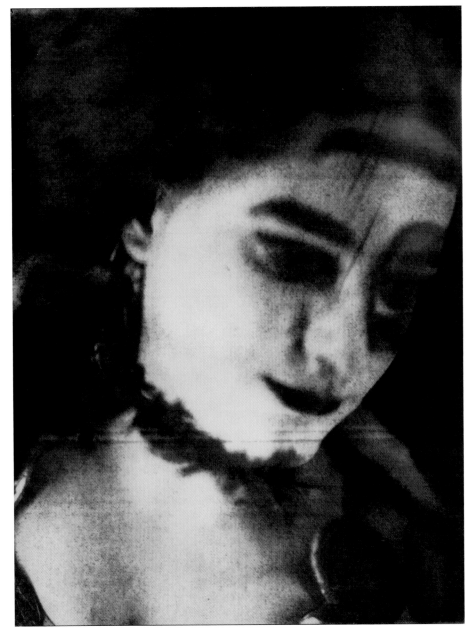

Martha Loving Orgain, *Magic & Mystery 4*, circa 1979. 3M Color-in-Color print.

Fourth in the series. Shading into Violet. Moving into the Mystery. The machine is making Orgain.

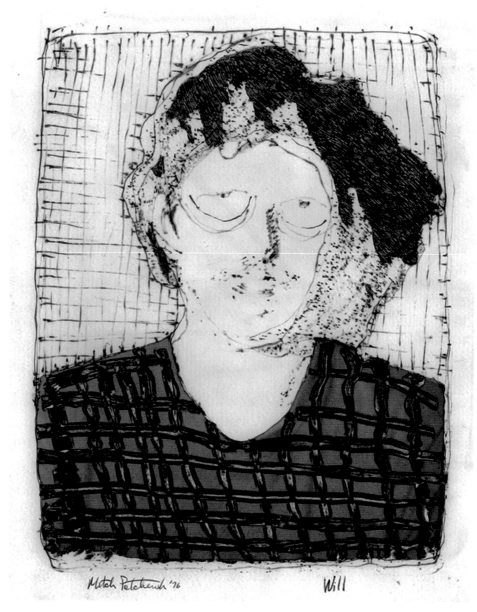

Mitch Petchenik, *Will*, 1976. 3M Color-in-Color 1 intermediate transfer onto Arches paper with soldering iron.

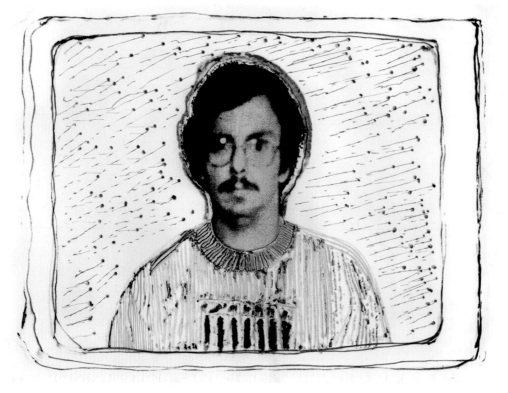

Mitch Petchenik, *Joe*, 1976. 3M Color-in-Color 1 intermediate transfer onto Arches paper with soldering iron.

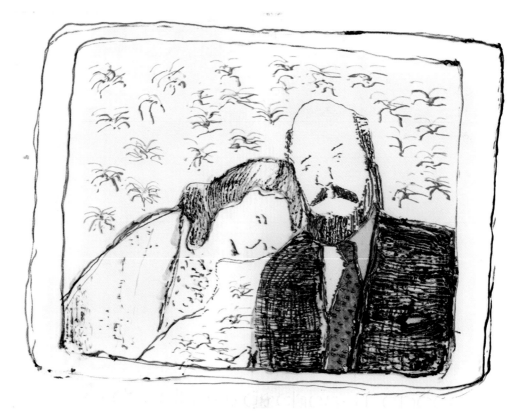

Mitch Petchenik, *Couple*, 1976. 3M Color-in-Color 1 intermediate matrix transfer onto Arches paper with soldering iron.

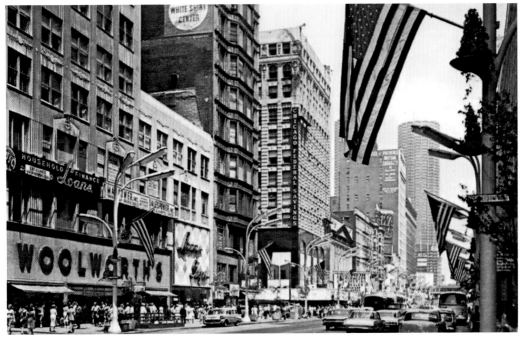

State Street, Chicago 1976. Photo by Chuckman's Collection

Mitch Petchenik, *Your Face Here*
A Generative Systems artwork by Mitch Petchenik
Time: 1975
Place: School of the Art Institute of Chicago, Illinois

The concept was simple. If everyone could use the street lamp posts to post sales and public events, why couldn't I use them to just post pictures of people's faces?

I decided to use "State Street," that great street, to post the images. I also had Ike follow me with a video camera.

The morning was spent using the 3M VQC black-and-white copier to do people's portraits. Once we had enough portraits we headed over to State Street with a white lab coat on and a bucket of wheat paste in hand.

I started to paste people's faces on the lamp posts along State Street. It wasn't long before two Chicago police officers appeared. They asked me what I was doing and they said I was defacing public property. I said no I was facing public property. It was at this point they walked me up State Street and made me remove all the faces I had put up.

Marilyn Goldstein Schultze

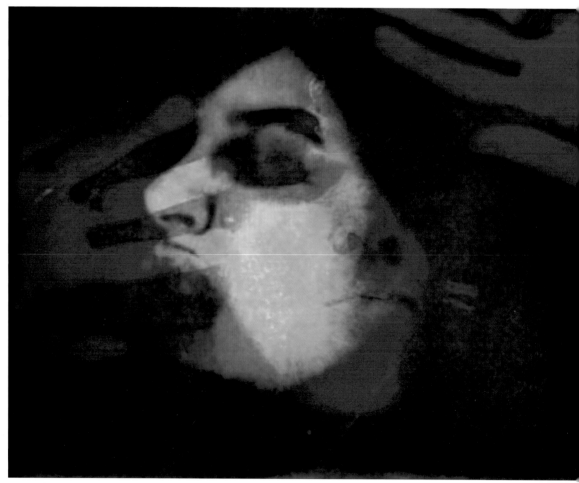

Marilyn Goldstein Schultze, *Self-Portrait,* 1971. 3M Color-in-Color 1.

Glenn Sogge, *A Facebook / Generative Systems Page / Faces and Hands Album*

Glenn Sogge placed this image on Facebook/Generative Systems with no further explanation or response. Perhaps it does not need one. I am, however, in this case, breaking the Generative Systems practice of the artists making their own selections of image and word.

Sometime in the 1970s Tom Willis, music critic and Northwestern University professor, introduced me to Glenn Sogge, his senior-year music student. That is how Glenn became a student in the School of the Art Institute of Chicago and established his connection with Generative Systems.

I follow Glenn's Facebook insertions with great interest, for more than anyone he poses questions, whether with word, or with image, or with selection of postings. He allows the viewer to wonder and to question. He stimulates. So he stimulated me to question this image, that I let the viewer now wonder about.

Sonia Landy Sheridan

Laurie Spiegel

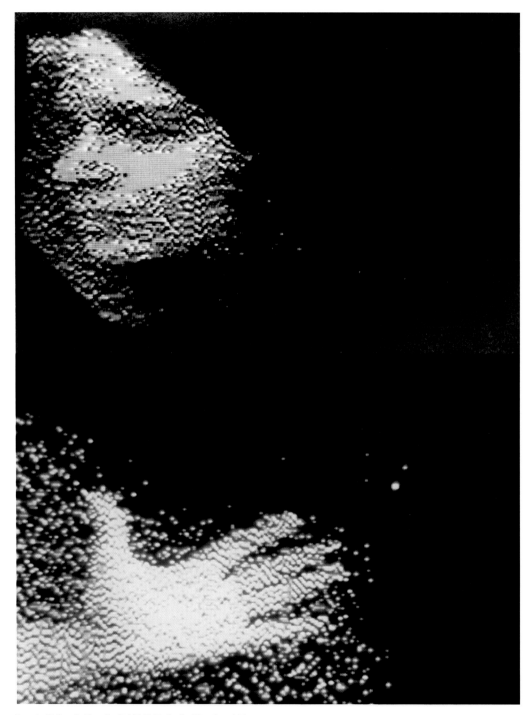

Laurie Spiegel, *Two Partial Self-Portraits: Hand and Face*

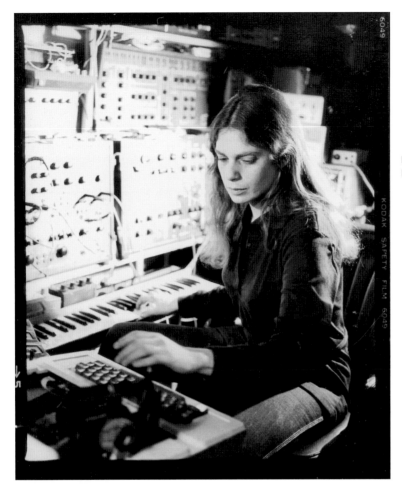

Laurie Spiegel working at Macro Works Digisector DS-6, circa 1980–82.

Laurie Spiegel Studio 86. Photo by Enrinco Ferorelli

Laurie Looking out of studio window.

I created the hand and face images on an Apple II computer with a Macro Works Digisector DS-65 video digitizer, a large DS-65 video digitizer, a large GPL 990 black-and-white television camera given to me by Steve Rutt, and my own software, which I wrote in 6502 assembly language with an Apple II Basic front end. I did not make note of the specific date when I created each of these particular self-portraits, but the image of my hand, and other similarly processed images, and my software were used in Wim Wenders's film *The State of Things*, released in February 1983, so their creation dates would have been a year or two prior to that.

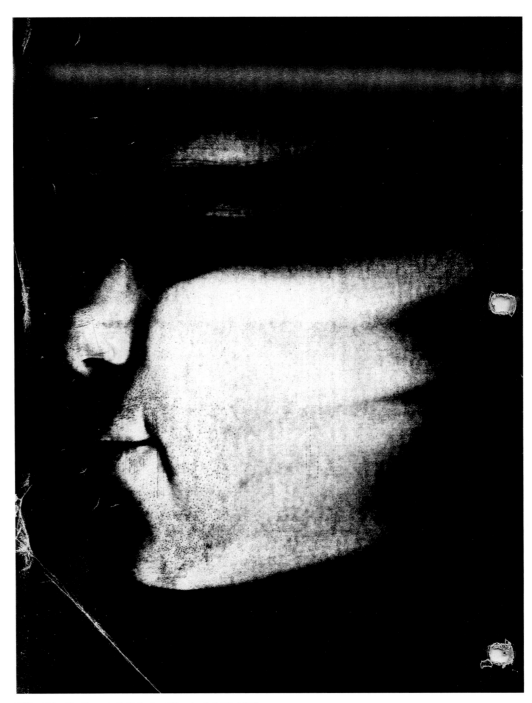

Willard Van De Bogart, *Self-Portrait Morphed*, 1978. VQC.

The evolution of morphing an image has recently been made into a new app for the tablet computer called Morfo 3D Face Booth. The app can take any photo and change its appearance and even add voice to it. Similarly, when Generative Systems was processing body parts with copy machines in the early 70s, the act of morphing had its beginnings complete with sound embellishments. The creative elements used for making those early images such as conceptualizing the flow of time or the palimpsest process of generating one image on top of another by modulating toner density was a way to extend the definition of self. The machines at that time took on the status of sentient beings and were looked upon as vehicles that could remake our existence. The 70s was a decade of the emerging persona of a machine-like culture. Forty years later my image still seems very familiar, not from any narcissistic point of view but as a representation of another form of human existence that was not yet defined in those developmental years. In retrospect, I think the Generative Systems group was a harbinger of a new world of digital art comprised of all the copied life forms, which eventually morphed themselves in time and now appear in the digital world of the 21st century striving to become immortal. In a way those early human representations now seem more supernal than surreal because today the super hero has become a puzzling collection of all those generated images that we so willingly and naively donated into those uncharted territories of the art world with the guidance of Sonia dressed in her white lab coat.

I was very interested in the concept of Generative Systems. The idea of continually sending sound or images from one machine to the next to see the variations of form was extremely fascinating. The idea as I recall for placing our faces on the glass plate of the copy machine was for me more than just copying my facial features. It was a process of taking our humanness and recording it with a machine similar to a camera taking a picture, but involving an entirely different technology using heat-sensitive plates and magnetized graphite. What was copied with this technique prompted a whole host of philosophical questions as to what really was the essence of being human when we integrate ourselves with a machine. These images are still being generated 40 years later and what they reveal is more about the symbiosis of the machine and man and his enduring legacy and collaboration on how humans invent machines and then ask those machines to speak back or feed-back their findings to our world. There becomes a blur between the definition of reality generated by the human or the machine and on whose terms is reality more of a representation of the world we live in. All these images represent to me the beginnings of a machine culture learning how to communicate with humans by trying to understand their nuances when they try to relate to the machine.

The mid-70s were the most exciting times to explore all these ideas and for me this was the essence of how I remember the Generative Systems workshops when I was at the Chicago Art Institute with Sonia.

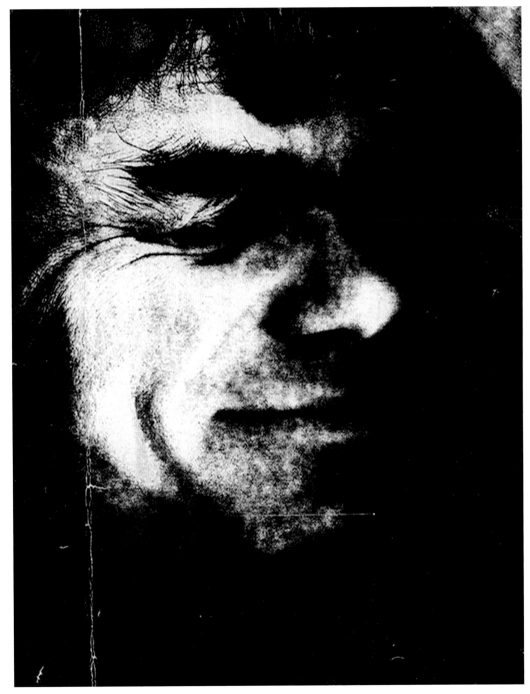

Willard Van De Bogart, *Self-Portrait,* 1978. VQC.

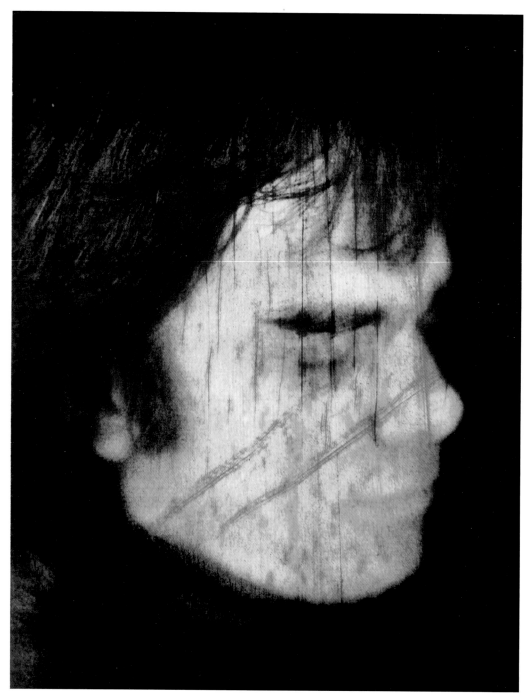

Philip Malkin, *Willard Van De Bogart,* 1978. 3M Color-in-Color copier.

The Contributors

Leif Brush

Leif Brush, Professor Emeritus, University of Minnesota at Duluth, created and taught the sound program "Audible Constructs" at the School of the Art Institute of Chicago from 1969 to1972. He became a leading pioneer in sound art with his own solar-powered, in-nature installations. In the words of two observers who studied these soundworks, "trees and wind became his Terrain instruments. His spacious garden was gradually transformed into an artist's studio."

Personal statement: I only came to understand trees when I heard their sap flow.
http://www.d.umn.edu/~lbrush/lbarchivesb1.html http://www.d.umn.edu/~lbrush/lbarchivesd1.html
http://www.d.umn.edu/~lbrush/lbarchivesf1.html
http://www.musica.be/en/windribbon-new-sound-installation-klankenbos

COSMO
See Bill McCabe

John Dunn

John Dunn bridged the worlds of art and science in his work as a composer and software developer. He has been a pioneer in computer music and art since the 1970s when, working as a graduate student in the Generative Systems lab at the School of the Art Institute of Chicago, he combined microcomputers and analog sound and video synthesizers. He was one of the early programmers for Atari video games, and he developed the first professional paint program for a microcomputer, Cromemco's Slidemaster, released in 1981. He went on to write a ground-breaking professional paint program for the PC, called Lumena, and founded Time Arts, Inc., of Santa Rosa, California, to market Computer Tools for Artists. Since the mid-80s he has been developing computer software for music compositions using generative algorithms based on sonification of data from stars to DNA.
http://www.algoart.com

Douglas Dybvig

Douglas Dybvig is a leading 3M scientist who developed the world's first color copier (Color-in-Color) with contributions from a great team at 3M. He has held high administrative positions at 3M, including Graphics Director in Great Britain and, at another time, a similar position in Japan. He has been an active participant in Generative Systems projects.

Personal statement: Sonia Sheridan broadened our vision to include its (Color-in-Color's) use as a new art medium.

Robert Frontier
See Bill McCabe

Marisa Gonzalez

Gonzalez is an outstanding European artist, well known for her imaginative use of new technologies in her creative work. She has been remarkably productive since the early 1970s and continues to exhibit widely in Europe, South America, and the United States. In 2012 she participated in the curatorial exhibition in the Giardini at the 13th Venice Architecture Biennale.

Personal statement: After graduate study at the very conservative School of Fine Arts in Madrid, I met Sonia in 1971 at her Generative Systems lab in SAIC. That changed radically my concept of art. It was the best thing that could have happened to me and to my art.
http://www.marisagonzalez.com

Jo-Anne Green

Born in South Africa, Jo-Anne Green has been Co-Director of New Radio and Performing Arts, Inc., since 2002. She is a teacher, curator, designer, and artist. Her paintings, prints, one-of-a-kind artist's books, and installations have been shown in Johannesburg, Massachusetts, and New York. She lives in Boston.
http://turbulence.org/jo

Greg Gundlach

Greg Gundlach graduated from Generative Systems at the School of the Art Institute in Chicago in 1980. After a wild career ride through teaching, fine arts, invention, entrepreneurship, and industry, he now has a graphic arts business in rural Vermont.

Personal statement: I try to see big patterns. I spend inordinate amounts of time trying to apprehend a limited multi-universe interpretation of relativity, aneutronic fusion, and liquid fluoride thorium reactors' potential for sustainable energy production, new variations of tired-light theory that obviate the Big Bang, and how we are integrating artificial intelligence into our lives. I dream of living in a more peaceful world, doing charcoal life-drawings on large sheets of paper.
http://www.vermont3d.com/
http://www.thestudiofordigitalservices.com/

Pete Lekousis

Personal statement: Graduated SAIC MFA Photography 1978. From 1974 to the present I have worked in commercial photography and university teaching environments. The artwork I did in the early 1970s (Generative Systems era) was a hybrid of mechanically generated renderings (photographic/machine) and hand-applied techniques (manipulated, coloring, cutting, drawing). These days (2013), the work is mostly digital photography, sometimes straight from the camera, sometimes manipulated in the same ways as before, and also using editing software.

Jacob Lillemose

Jacob Lillemose is a writer and curator based in Copenhagen. In 2011 he received his PhD from the Institute of Arts and Cultural Studies at the University of Copenhagen. His dissertation was titled *Art as Information Tool: Critical Engagements with Contemporary Software Cultures*. Since the mid-1990s he has worked internationally with projects focusing on the tradition and legacy of conceptual art within a contemporary media context. His curatorial work in the field of media art includes the Trransmediale Festival in Berlin, 2012–13.

http://www.transmediale.de/content/jacob-lillemose

http://www.artnode.org/art/lillemose/index.html

http://www.youtube.com/watch?v=u_PuJorduPg

Joan Lyons

Joan Lyons has combined two careers in the arts. On the one hand, she has been a productive practicing artist. She has worked in a great variety of media, including pinhole photography, offset lithography, Xerography, archaic photographic processes, computers, and still other media. Her prints and books are in many collections. At the same time, she was the Founding Director of the Visual Studies Workshop Press, a leading publisher of books relating to the history, theory, and practice of the arts. Among many other things, she is the editor of the annotated bibliography *Artists' Books: Visual Studies Workshop Press, 1972–2008,* published in 2009, as well as *Artists' Books: A Critical Anthology and Sourcebook*, published in 1985.

http://www.joanlyons.com

John Mabey

John Mabey is an independent producer, multimedia artist, and researcher. He currently lives and works in Northern California.

http://www.fondation-langlois.org/html/e/page.php?NumPage=2055

Philip Malkin

Philip Malkin has pursued a career as an artist and has worked in the fields of photography, video, and interactive content development. He currently lives and works in the Pacific Northwest where he is also an Art Commissioner with the City of Bellevue, Washington.

Personal statement: I have tried to understand how the creative process works and it continues to be an activity of discovery. Every day I learn something new about what art is. I feel thankful for this.

http://www.malkin.net/photos

Bill McCabe

When they were both students at the School of the Art Institute of Chicago, Bill McCabe and Robert Frontier joined together in a team they called COSMO. Until Bob died at the young age of 25, COSMO brightened the Chicago world with witty observations in the form of giant banners, signs, posters, and books. They were a vital part of the stimulating environment at SAIC that prepared the way for Generative Systems. Since that time, Bill McCabe has lived and worked on the west coast, where, Bill says, "I have always sought unconventional forms and outlets for modern artistic expressions: a zoo, cable TV, and the internet." Current works are available at: www.facebook.com/wfmccabe/photos_all

Brian Oglesbee

Brian Oglesbee studied at SAIC from 1970 to 1974 and participated in the Generative Systems program. Since that time he has pursued a career as a fine-art photographer in New York State. http://www.oglesbee.com/
http://www.oglesbee.com/aquatique.html

Martha Loving Orgain

Martha Loving, MFA, Art Institute of Chicago, Generative Systems, is an artist, educator, and astrologer creating Star Chart Talismans™ with watercolor, photography, printmaking with 3M Color-in-Color dye sheets, and drawing. Trained in the Waldorf/Steiner school methods, Martha teaches watercolor and meditation to all ages throughout the US. She trained in Collot Painting Therapy in the Netherlands and is one of six such therapists practicing in the US. She holds diplomas from the Netherlands and Switzerland.

Personal statement: Working with Spirit, Nature, Light, and Darkness, magic and mystery permeates my work on many levels. I'm well into my "next career"—working with Elders and fairy tales—using Goethe's work "The Green Snake and the Beautiful Lily," a tale of transformation of the soul. I love the summers here in Vermont and am tending BEES in my biodynamic garden, and watching COLOR MOVE.
http://www.lovingcolor.org/id4.html
http://www.lovingcolor.org/

Mitch Petchenik

Born and raised in Brooklyn, New York, Mitch Petchenik studied photography at Rochester Institute of Technology. Petchenik met Sonia Sheridan at a Visual Studies Workshop in Rochester, and went on to study and work with Sheridan at the School of the Art Institute of Chicago. Petchenik now develops web properties on the Internet.

Marilyn Goldstein Schultze

Personal statement: Born January 3,1951 in Chicago, Illinois, to a very artistic and eccentric mother. I was enrolled into a painting program at the Art Institute at age five and returned to go to the School of the Art Institute at age twenty, where I luckily met Sonia Sheridan and discovered Generative Systems. After graduating with a degree in Generative Systems/Performance Art in 1973, I relocated to Northern California with my future husband, Louis Schultze, in 1973 to join the back-to-the land movement. To make financial ends meet we became San Francisco Street Artists and evolved into selling our art creations up and down the coast of California at arts and crafts fairs during the 70s and 80s and finally selling in boutiques and galleries. I had my son in 1990 and then began a teaching career in 2002 through 2010 to share my joy of art. I am retired now but I am not tired. I continue to make art as it suits me.

Jim Sheridan

The contributors to *Art at the Dawning of the Electronic Era: Generative Systems* thank Jim Sheridan for his essential participation in its production.

Sonia Landy Sheridan

Sonia Landy Sheridan is an artist and Professor Emerita, School of the Art Institute of Chicago, and founder of the Generative Systems program at SAIC. The primary collection of her art work is in in the Hood Museum of Art, Dartmouth College. Her work is also represented in museum collections in Europe, Japan, South America, Canada and, of course, in the United States. The Fondation Langlois in Montreal, Canada, has archived all of the records of Sheridan's Generative Systems program as well as large bodies of her work created after 1960.
http://sonart.org
http://soniasheridan.com
http://www.fondation-langlois.org/html/e/page.php?NumPage=2055
http://dartmouth.edu/search/gss/sonia%20landy%20sheridan

Glenn Sogge

Personal statement: As I have more fully integrated the "aesthetic stance" into my life, I find more application of the aesthetic stance but less need for objects mostly defined by that stance.

Laurie Spiegel

Chicago-born composer Laurie Spiegel is also a computer programmer, software designer, and visual artist. She is best known for her pioneering work with several early electronic and computer music systems. Her focus has been largely on interactive software using algorithmic logic to augment human abilities. Her best-known work includes that with the GROOVE Hybrid System at Bell Telephone Labs, the early online transmission of digital music, and "Music Mouse—An Intelligent Instrument" for personal computers. She has taught at Cooper Union and NYU. In the early 1970s, she designed and programmed one of the very first digital "paint" programs as well as a realtime interactive video instrument. In addition to technologically-based works, Spiegel does traditional art and music on paper and continues to love old as well as new arts media. She has authored various papers, available, as is some of her music and art, on her website http://retiary.org.

Willard Van De Bogart

Personal statement: It was EXPO 67, Man and His World, in Montreal, Quebec, that became the catalyst for a career in applying Art and Technology to the disciplines of educational technology and the performing arts. First, to enter the California Institute of the Arts in 1970, mentoring with Morton Subotnick and Nam June Paik, then Generative Systems in 1971 with Sonia Landy Sheridan, and then working with Nicolas Schoffer, father of cybernetic art in Paris; my intent was always to explore how art and technology could provide a platform for discovery and innovation. Currently in Thailand developing a research project at Bangkok University in the Language Institute, which integrates digital assistants and tablet computers within an educational curriculum in the ASEAN community that explores digital literacy skills for the 21st century.
http://www.earthportals.com/cosmicjorny.html

Stan Vanderbeek

Stan Vanderbeek was the consummate artist. He absorbed images like the latest computer. He searched for any system that would provide him with new insights. With great humor and warmth of person he reached out for anyone to join him on his path to discovery. He died in 1984 and missed the Internet, to which he would joyfully have added his own insights and humor. We know that he would have wanted to be with us now, so we have brought him along to live in our cyberspace.
http://www.stanvanderbeek.com/cyberspace.
http://en.wikipedia.org/wiki/Stan_Vanderbeek
http://www.amazon.com lists works by and about Stan Vanderbeek.